DESIGNERS

IN HANDCUFFS

HOW
DESIGN BOOKS
Cincinnati, Ohio
www.howdesign.com

DESIGNERS
IN HANDCUFFS

*How to create great graphics
when time, materials
and money are tight*

Pat Matson Knapp
designed by Lisa Buchanan

07 06 05 04 03 5 4 3 2 1

Library of Congress Cataloging-in-Publication Data

Knapp, Pat Matson.

Designers in handcuffs / by Pat Matson Knapp.

p. cm.

ISBN 1-58180-331-1

1. Computer graphics. I. Title.

T385 .K5667 2003

741.6'068--dc21

2002032709

Editor: Amy Schell
Editorial Assistance: Eric Schwartzberg
Designer: Lisa Buchanan
Production Coordinator: Sara Dumford
Page Layout Artist: Matthew DeRhodes
Illustrator: Andrew McGuire

Acknowledgments

With grateful acknowledgment to Clare Warmke of
HOW Design Books for her thoughtful guidance and
keen eye; editor Amy Schell for her enthusiasm and
great ideas; Bryn Mooth, Sarah Morton and the staff
of HOW magazine and HOW Online for their support
and contributions; Tricia Hill for her many Mac trans-
lations; and Lisa Buchanan for her innovative design.

Dedication

This book is dedicated with respect and warmth to
the contributors—design stars every one.

About the Author

Pat Matson Knapp is a Cincinnati-based writer and
editor whose work focuses on design and its effects
on business and culture. A former newspaper journalist,
she was editor of *IDENTITY*, a magazine devoted to
environmental graphic design and corporate identity,
and was managing editor of *VM+SD* (Visual Merchan-
dising and Store Design) magazine. She has written
for a wide range of design publications and is the
author of *Designing Corporate Identity: Graphic
Design as a Business Strategy,* published in 2001.

Table of Contents

3

Rocky Relations
p. 102

Techniques for working effectively
with clients, suppliers and colleagues

4

Creative Challenges
p. 146

Real-world solutions to design roadblocks

Introduction

Budgets that don't pass the laugh test. Schedules that rede-
fine the word "harrowing." Printer problems. Albatross artwork.
Clients who might as well be speaking another language.

You understand, of course, that problems are part of
the learning process. That obstacles make you stronger.
And that a steady diet of challenges will make you a
better designer.

But wouldn't it be nice if you didn't have to learn
everything the hard way? If someone—some wise old
mentor—gave you the keys to unlock those handcuffs?
Made you his own personal "Grasshopper" and whispered
secrets of the trade in your ear?

Welcome to *Designers in Handcuffs,* a resource guide that
provides hands-on, in-the-trenches solutions to design's most
frustrating obstacles. You'll find a wide range of design solutions,
from Flash tricks to cheap-but-eye-popping printing techniques.
You'll find ways to jump-start your creativity and learn how to
spot a difficult client from a mile away. You'll also learn how
experienced designers handle client relations and communicate
with their vendors to ensure trouble-free projects.

Designed and written as a quick-read reference tool, *Designers
in Handcuffs* is organized into four major areas of constraints: Time
Trials, Money Matters, Rocky Relations and Creative Challenges. Each
section is indexed so that when you encounter a problem, you can pick
it up, leaf through the index and quickly find solutions. Every page
contains useful anecdotes, checklists and tips and tricks that will
unlock those handcuffs—and set your design spirit free.

"Time: wait[s] for no man."

—Geoffrey Chaucer, from A Clerk's Tale

As a designer, time is your most precious commodity. And often, there's way too little of it. For most design professionals, racing the clock is second nature and maximizing the time you have is one of the most important skills you can develop.

But no matter how efficient you are, there are only twenty-four hours in a day. And since you can't stop the hands of time, the next best thing is to beat the clock in as many ways as possible.

This chapter will add to your collection of great time-saving tricks. In the following pages, veteran designers share the shortcuts and time-savers they've spent years discovering. From the conceptual (such as how to work with your client to develop a realistic schedule) to the nitty-gritty (including some great software shortcuts), the following pages will give you the tools you need to go a few more rounds of "Beat the Clock" while producing the best work possible for your clients.

TIME TRIALS

TIPS AND TRICKS FOR MEETING [AND BEATING] THOSE IMPOSSIBLE DEADLINES

Turn an Impossible Deadline into a Realistic Schedule

Stay calm, and work with your client to develop a plan

If your client comes to you with an impossible deadline, the first thing to remember is to always be objective (not emotional). Often the deadline was not set by the person who brings it to you. Remember that the goal is to keep your clients happy and continue doing work for them.

Therefore, your best approach is to work closely with the client to identify a development strategy. Explain why the full scope of work can't be delivered in the time required, but also discuss what can be done in that time frame. This provides the client insight into what can realistically be accomplished without compromising the quality of work.

—Rhonda Conry,
Conry Design, Topanga, CA

"SAY 'NO' TO UNIMPORTANT TASKS."

—Bob Bapes,
Bapes & Associates, Oak Park, IL

Get Fewer Complaints by Setting Time Constraints

`Increasing client responsibility will smooth the journey`

If you set up a project schedule at the start of a project, you'll have an outline of every important date from comp presentation to revisions to production, printing, shipping and delivery. Print it up and let the client sign off on it. That way the client shares the responsibility in delivering approvals and materials on time. If that doesn't happen, revise the schedule and have them sign off on the new one. Following this practice can help make every project a smooth one.

—Peleg Top,
Top Design Studio, Toluca Lake, CA

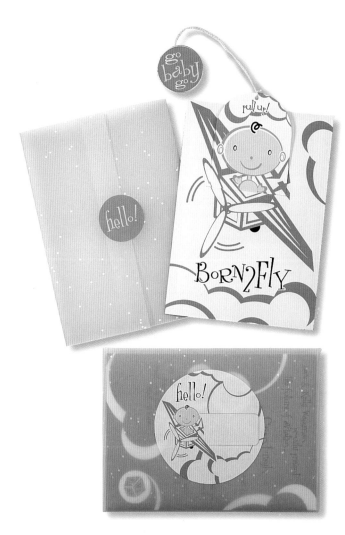

Design an Outer Carrier as a Quick Envelope Replacement

Save lead time (and money) on custom envelope production

When you design an invitation, the client often wants the envelope to be eye-catching in some way, whether from special papers, colors, inks or other devices. The problem is, most invitations are short runs of a thousand or less, which means the envelopes must be custom made. This can take up to a month (and cost dearly). As an alternative, create an outer carrier that folds on the back side and can be sealed with a wafer seal or "hot dot." The printer just needs to create a template for it, print it, score it and fold it. This can be done quickly and provides the look of a "special" envelope for a lot less money.

—Catherine McNally,
University of Maryland University College,
Adelphi, MD

This unique birth announcement was created by Cheryl Roder-Quill of angryporcupine (Cupertino, CA) to celebrate the arrival of the "little co-pilot" born to two pilot parents. The vellum envelope is secured with a digitally printed wafer sticker, so a special envelope was not required.

Streamline the Concept Phase
by Categorizing Themes

`Save time and resources by asking the client`
`to edit concepts`

We recently worked with a real-estate developer who needed to get some quick marketing materials to their target audiences. To ensure that we stayed on schedule (and budget) we incorporated some fast-track methods during the concept and presentation stages.

Our creative team had lots of great ideas for a direct-mail campaign. But rather than offer the client a large number of ideas (which would take us time and resources to flesh out), we first approached them with different categories or themes that a campaign might be built around (for example, games, exploration, local attractions). The client was able to give us quick feedback and more accurate direction than we would have received from a creative brief. This allowed us to use time and resources more efficiently. We also presented the entire initial concept in written form rather than creating time-consuming story boards. This won't work for all clients (many of whom need visuals to choose a design direction), but it worked well for this client and allowed us to stay on schedule and budget.

The key to using a shortcut method like this is to stay laser-focused when receiving feedback on what the client does and does not like about a campaign theme. The discussions should be based on objective criteria that have already been established so feedback can be used quickly and effectively to move the project forward.

—Bonnie Jensen,
Girvin Inc., Seattle, WA

Use ImageReady's Droplet to Create Thumbnails

This trick makes them fast and easy

An ImageReady droplet is your best friend when you're creating thumbnails or gallery-style photos for web sites. Record an Action in ImageReady to adjust the image size to suit your needs. Then in the arrow drop-down on the Actions palette, go to Create Droplet. Then drag your inventory of images onto the droplet and watch it go. Note: Make sure the Optimize palette is set to your requirements, as the droplet will use this as its optimization reference.

—Matthew Wearn,
Suibaku, Toronto, ON

Account for Each Minute of Work

When I first entered the industry I worked at a firm that required all designers to submit a fifteen-minute-by-fifteen-minute journal that detailed the exact nature of the work being done at every moment. I wasn't alone in believing that this method of documentation was more than a little obsessive on the part of the owner. I soon came to understand, however, that detailing the division of labor between say, hand sketching, computer rendering, comping and service-provider dialogue was beneficial to me as a designer in more ways than one. The obvious benefit was that such documentation would allow a concise itemization for the client when it came time to bill them. Giving them an exact breakdown often prevented needless bickering if the job ran over the original estimate.

The second benefit is more far-reaching and gets to the heart of the matter. By accurately recording the specific labors of design jobs over the course of my career, I have eventually developed a keener understanding of exactly how much time I need to complete certain facets of a particular job. As a result, my future estimates are as accurate as they can possibly be.

Keeping a detailed journal will allow you to look back on past jobs in order to assess what type of work you breeze through as a designer, and what type of work slows you down. Although it may seem like an unnecessary nuisance, it will make you a better business person in the long run.

—Scott Boylston,
Savannah College of Art and Design, Savannah, GA

Check Quark's Usage Dialogue Box

Save time by checking links and fonts

Although QuarkXPress has a handy Collect for Output feature, I always check the Usage dialogue box under the Utilities menu. This does two things: First, by updating all the images to OK status, I can make sure they make it onto my disk in a correct link. Second, this is the only place I can see all the fonts I've used.

—Linda Athans,
Athansdesign, Clearwater, FL

> **"A sloppy file only creates more time on the back end."**

—Gerard Huerta,
Gerard Huerta Design Inc., Southport, CT

Fine Tune When the Job is Done

Don't let the perfectionist in you sabotage a project

Being a recovering perfectionist, I've struggled with the issue of tweaking little details for most of my career. I think the key is to stay in tune with the big picture. That is, don't obsess over every little detail...until the job is almost done. Much time can be wasted perfecting kerning, alignment and other details when the job might have to be reworked several times. At the end, you can fine-tune to your heart's delight, as long as you stop when you become the only person who will appreciate your efforts. Keep a rough time table of the stages of your work and try to stick to it. If you keep going over everything, you'll either need to increase your pricing in the future or get used to working for less.

—Ilene Strizver,
The Type Studio, Westport, CT

Teach Your Client About the "Golden Triangle"

Make your client aware of the "Golden Triangle" of price, quality and speed. While the goal is always to maximize all three of these factors, each is often gained at the expense of the others. So determine what your client must have, and what they can cut corners on:

- If time is the most important factor, either the price should go up to compensate the vendor, or parts of the process must be skipped and therefore quality suffers.

- If there can be no mistakes, it will either take more time for quality assurance, or more resources will be required.

- If there is no money, the vendor either needs to cut corners on quality assurance or the project will become a low priority compared to more profitable projects, thus taking longer to complete.

—Day Kirby,
Communicopia Internet Inc., Vancouver, BC

"You must be able to manage expectations:
You can have it cheap.
You can have it fast.
You can have it good.
But you can't have it cheap, fast and good.

Pick any two."

—Bob Bapes,
Bapes & Associates, Oak Park, IL

Choose Type in a Hurry

`This handy guide helps simplify an`
`overwhelming amount of font choices`

With more than 20,000 typefaces available—and font houses grinding out more almost daily—designers aren't exactly starved for choices when it comes to type. As a matter of fact, sometimes the sheer volume of possibilities can be overwhelming, and if you're in a hurry you may not have time to shop. To expedite the process, use these guidelines and the typographic wheel to narrow the field.

- Choose serif typefaces for classic-feel pieces (law, health care, corporate). In general, the more serif, the more elegant or classical the look.

- Choose sans-serif typefaces for more modern or edgy pieces (high-tech, financial, young markets). In general, the more serif, the more modern the look.

- Use script typefaces sparingly, for elegant pieces (invitations, announcements, etc.).

- Choose typefaces to communicate specific qualities or to evoke emotion. For example, a classic serif typeface such as Garamond communicates a feeling of dependability and quality, while the sans-serif face Bank Gothic is clean and understated, with a contemporary look that communicates confidence.

- Choose typeface combinations carefully, selecting no more than three for each piece—one each for headings, body copy and accent type. The typographic wheel is a handy guide for type combinations.

- Choose a heading typeface style (e.g., serif).

- Use the typestyle (or its parent style) opposite for body copy (e.g., serif and sans italic or serif and sans serif).

- Do not use close relatives of the main typeface as body copy (e.g., serif and medium serif or script and italic serif).

- Do not use more than three different typefaces per piece (one for the headings, one for body copy and one accent type).

—Ryan Harper,
Harper Creative, Millville, UT

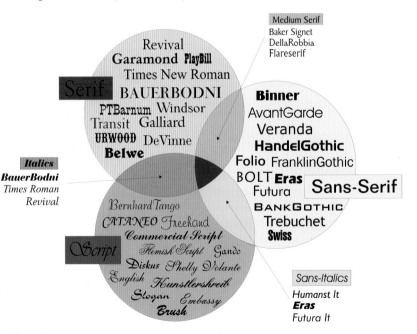

Establish a "Black Box" Process

Using a standard process increases your efficiency

Develop a "black box" process customized to your firm and follow it flawlessly every time on every job. This is a set method for how you do your work and it's what defines what you do with each job, client and set of resources every step of the way, beginning with the time a prospect contacts you and ending with the final payment for the work you've done.

—Lori Walderich,
Idea Studio, Tulsa, OK

"If everyone on the team is on the same page then the process is more productive and ultimately produces better solutions."

—Elaine Cantwell,
Spark, Hollywood, CA

Don't Be Afraid to Ask for Help

`On tight deadlines, tech support can be`
`your best friend`

Here's a tip that helped me when I was developing a new department. I was working with a promotional products company that had just purchased a computerized embroidery machine to produce in-house embroidery designs for national customers. I was learning the new software and producing products at the same time. Computerized design is a field I didn't learn about in art/design school, so I had to train myself to account for factors such as how the software calibrated stitches of color per needle and how the pushing and pulling of fabric during embroidery affected the designs.

When things got sticky, tech support was my savior. I divided my screen in half, keeping the software company's tech support online in one window and the graphics software itself on the other. I also kept a small web search window open at the bottom of my monitor to quickly get to any graphics support site I needed to access. Often, I had tech support or the embroidery hardware company on speaker phone in the production room walking me through a malfunction or software glitch. During the hectic time while the department was under development, having tech support at my fingertips at all times was crucial. A final note: Making contact with the same person at tech support each time was also critical, because she became familiar with our problems and was able to respond quickly and easily.

—Shelly Prisella,
Digity Dezigns, New Brunswick, NJ

Prepare Documents for Efficient Prepress and Print

When prepress/print time comes around, the steps you've taken to prepare documents correctly can save you precious time and allow you to meet that tight deadline. Follow these guidelines and your documents should sail smoothly (and quickly) through prepress and output.

PHOTOSHOP

- Make sure that image resolution is sufficient for your line-screen. Use this basic formula: ppi= linescreen x 2. Thus, if you're printing at 133 linescreen, minimum ppi is 266. Higher resolution will not improve the printed product and will slow output at your studio and the print shop.

- Crop images to just outside the picture box. Leave approximately ⅛" past the picture box on each edge in case a tiny nudge is necessary at the printer.

- If you are using FPO images for the printer to replace with high-res, keep them small (72 ppi), and place a mark in the center of each image using the Photoshop type tool "FPO" to ensure these will be swapped out.

- Rotate and flip images in Photoshop, and place in Quark at 0% rotation. This will make a considerable difference in output speed for you and your printer.

- Change from RGB to CMYK. Use a Pantone spot-to-process book (not your monitor) to check colors.

QUARKXPRESS

- Delete unused colors.
- Name spot colors in Photoshop or Illustrator identically to Quark spot colors.
- Use the Collect for Output feature.
- Check picture and font usage to make sure you've gathered all fonts (both screen and printer fonts). Quark's Collect for Output function does not collect fonts.
- Get familiar with DCS (Desktop Color Separation) .eps file format for use in your Quark layout. If you work in this format, you'll save hours in time spent on printing. "Hide" the .c, .m, .y and .k files in a temporary folder, so Quark will be forced to print only the preview held in the .eps link file. Note: When you do this, you will receive an error message in Quark which tells you the color plates cannot be located. For quickie printouts, some printers insist on single-format .eps files; in this case, use DCS files for your working copy and save a flattened composite .eps of each image prior to Collect for Output. When you collect files for output for your print vendor, move the plate files back to their original locations. The printer must have all five files to output your job. If you plan to color correct or otherwise alter your image (crop, rotate, etc.), make sure all files are in the same location so all five can be updated and saved to the newest version.

—Jackie Cuneo,
Watermark Graphics, San Francisco, CA

Use PowerPoint for Client Presentations

It's not your favorite "designer" software, but it works-and fast

If your client has stepped up a presentation meeting time and you don't have time to create presentable hard-copy comps or live interactive comps, plugging screen shots or graphic files of your comps into PowerPoint with a black or dark gray background is a nice quick fix. It looks professional, the client perceives you as tech savvy, and if the PowerPoint file doesn't end up too large, you can e-mail it to them afterward for review (most clients have MS Office available to them). You can also print it quickly and type in notes for the presentation.

—Conan H. Venus,
Velocity Partners Inc., Holland, MI

For quick and professional client presentations, plug screen shots or graphic files of your comps into PowerPoint.

Identify Your "Handcuffs" Before You Start Work

Know what questions to ask your clients—and not just the design-related ones. Always find out any size, color, paper, mailing, budget or deadline constraints before you start work. Doing so will set your parameters; nothing hurts more than having a killer design, only to have it squashed because the production can't happen the way you wanted it to. Also, ask clients for examples of other work they like, and discuss why they like each piece and what elements of them they'd like to incorporate into the project at hand. The more information you're armed with, the more smoothly your job will proceed. In a nutshell, listen and be proactive instead of reactive.

—Linda Athans,
Athansdesign, Clearwater, FL

"I save the most time by accepting the unexpected twists and turns.

Instead of wasting time worrying about changes, I offer and develop new positioning and refocus the project as needed."

—Jackie Merri Meyer,
Warner Books, New York, NY

Make Seconds Count When Opening and Closing Files

If you added up all the time it takes you to open and close files, you'd be surprised by the total (and you could go to lunch instead of staying hunched over your computer). Sometimes seconds count, so follow these tips to make the most of your time:

- Unless you have a file open, don't bother closing all those windows before you eject a CD. CDs don't have memories and won't be affected.

- Use the command keys. If you become proficient at using them, you can have a file opened and working before anyone who uses a mouse. Keep your hands on the keyboard.

- Keep your files organized. Fonts should be all in one folder (divided by serif, sans serif, display and script, for example), images in another and so on. Having to hunt for where you last kept a file or what you named it eats up a lot of time.

—Gary Unger,
Graphics Crisis?
Call Gary!, Atlanta, GA

Refine your (Illustrator) Copy Skills

If you need to make exact copies of shapes, text or anything else in Illustrator, select the object, keep the mouse button depressed, hold down Shift+Option+Command, and drag the mouse to another position. (Your cursor will change to a double arrowhead—one white, one black.) Release the mouse and let go of the keys. The "copy" will drag over in a constrained direction. You can also drag objects without constraining them by holding down Option+Command as you drag. This takes a little practice, but once you get it, you'll use it all the time!

—Linda Athans,
Athansdesign, Clearwater, FL

When Time Management Goes Awry

Three rules for better productivity and efficiency

- Don't be a procrastinator! Think ahead and plan—not just one job, but everything that's consuming your time. Get some type of planner, whether it be electronic or paper, and keep it up-to-date. Try to effectively balance the work load by looking at the "big picture."

- Identify when you're working efficiently and when you're spinning your wheels. If you're not making any progress on a job, switch to another for a change of pace. Once you've gotten tired of that job, switch back to the first and you'll have a fresh perspective. This can be particularly helpful when there's a lot on your plate.

- Don't panic. You can usually get more done than you think, but it requires your full attention. Make sure you don't waste your mental and physical energy worrying. Spend that same energy on the task at hand.

—Peg Faimon,
Faimon Design, Oxford, OH

"Delegate outcomes, not process."

—Bob Bapes,
Bapes & Associates, Oak Park, IL

Create a Pop Art Look Quickly

To create a pop art look for any flat illustration, open any Illustrator document in Photoshop. Make sure the image is at least 150 dpi and in CMYK format. Open the channels palette. Select the cyan channel. Choose Filter>Pixelate>Color Halftone. Use Max Radius at 6, and the defaults for the screen angles. Then choose the magenta channel and use the same effect (Command+F as a quick key). Choose the composite channel again, and voila! Lichtenstein would be proud!

Note: This also works in RGB mode—just choose blue and red. The results may not be light-table identical, but the effect is similar.

—Linda Athans,
Athansdesign, Clearwater, FL

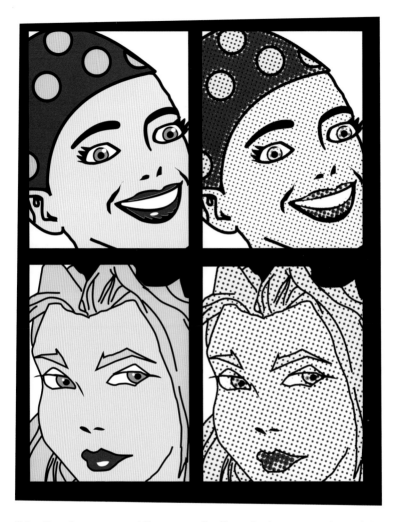

Using Photoshop, you can quickly convert a flat illustration into a pop art image that Roy Lichtenstein would love. This trick works best with black-outlined images.

Top illustration by Linda Athans, bottom illustration by Rob Epps.

Five Factors to Consider When Choosing Colors

Your quick guide to color choice

Brent Haley, director of sales for Pantone, suggests designers keep these five considerations in mind when spec'ing color.

- Paper. Make sure you explore the various paper stocks the identity may be printed on. Color printed on recycled, speckled, tinted and uncoated stocks looks different than when reproduced on a coated white sheet.

- Match color. Remember that only about 45% of Pantone colors are accurately reproduced in CMYK. If the design will usually be reproduced in four-color printing, it's best to limit your selection to colors that are accurate in CMYK.

- Emotion. Color gives emotion to a corporate mark. Be sure your color pick gives the appropriate impression to your client's target audience. Blue and green, for example, convey confidence; red implies forward thinking.

- Cultural perspective. If you're creating a mark for international use, consider the significance of color in other countries and cultures. The web is a good resource; visit webdesign.about.com/library/weekly/aa070400c.htm to see what different colors mean to various countries.

- Trends. Don't pick trendy colors. A company brand must stand the test of time. The hot pink that was popular in the 1980s and the teal that ruled the early 1990s now look remarkably dated.

Adapted with permission from "Corporate Colors," HOW magazine November 2001, by L. Payne

Create a "Ghosted" Area for Overlaying Text

Here's a quick and easy Photoshop guide

To create a "ghosted" area in a photo in which to overlay text, first open the photo and determine where the text will go. Use guides to define a rectangular area for the ghosting effect. Choose Layer>New>Layer (Command-Shift-N) to create a new layer. Be sure that layer is selected in the Layers palette. Choose the rectangular Marquee tool, and use the Select>Feather command to feather it about 20 pixels. Draw the marquee inside the guides, and use the Paint Bucket tool to fill it with white. Then use the Opacity slider in the Layers palette to reduce opacity to the desired level (about fifty percent or so, depending on the image). Flatten your image and save as a TIFF. Now when you import, you will have a "clean" area in which to place text without sacrificing your photo.

—Linda Athans,
Athansdesign, Clearwater, FL

Get Site Map and Content Approved Early

Early review saves time and hassles in web site production

Before you begin design and production of a client's web site, ask them to review your proposed site map and content. Doing so simplifies the process and helps you avoid redoing navigation and HTML templates, a time-consuming and expensive task.

—Savage Design Group Inc.,
Houston, TX

"You always know in your gut whether it's RIGHT or NOT..."

—Elaine Cantwell,
spark, Hollywood, CA

38

Encourage Clients to Approve Work Online

Posting your work on the web streamlines the review process

Before we make the final color and print check, I sometimes post a project online, so everyone involved can review it and make minor adjustments. (A word of warning: Make sure clients understand that the color they see on screen is not necessarily what they'll see on the printed piece.) Here's how to do it:

- Convert the file from CMYK to RGB

- Use Photoshop's Image Size command to reduce the resolution from 300 dpi to 72 dpi

- Save the Photoshop file as a JPEG, using the highest "quality" setting (12)*

- If your layout is in Quark, save your file as an EPS and open it up in Photoshop

- If you have large 300 dpi images, convert them first to 72 dpi so Photoshop will open the EPS faster

- Make sure you have the right fonts loaded, or Photoshop will quit on you

- Create an "ftp" area for your client, post the file and send them the URL

* JPEGs tend to get blurry when saved down to a more web-friendly resolution, so saving the file on a higher "quality" setting helps preserve the color and image.

—Cynthia Petty,
Dahlia Digital, New York, NY

Don't Reinvent the Wheel

Our client, a Michigan-based marketing fulfillment company, needed a web site redesign. Their existing site was extremely dated and inconsistent with any of their other marketing materials. We were given a brochure, a postcard, a video and a questionable Flash piece and asked to create the web site. With a small budget and a production schedule of just four weeks, we quickly cut to the chase: The client needed a consistent overall brand presentation and a professional online presence. Realistically, we could not totally rebuild their branding program within the time and budget allotted, so our solution was to maximize their existing marketing materials without reinventing the wheel.

The best item in their collateral was a fun, colorful brochure that successfully communicated the personal side of the company's business. This became our design driver for the web site. To save money, we used existing photos and enhanced them with a couple of low-cost stock images. Our solution connected the brochure and web site visually, giving our client a much stronger identity without requiring them to pay for additional branding elements. It also gave new life to the existing brochure because the company now has a more fresh, up-to-date identity linking the brochure and web site. The client was extremely happy with the results and has received rave reviews from current and potential clients.

—Conan H. Venus,
Velocity Partners, Holland, MI

Velocity Partners (Holland, MI) didn't have the time or budget to create a totally new brand identity for its client, a marketing fulfillment company. So they chose a strong existing collateral piece (bottom) as the visual springboard for the company's new web site.

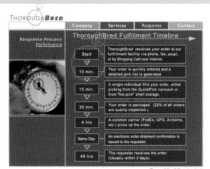

Time is Money

Keeping your design team on task and your client on target

First and foremost for any project, we create a well thought-out, realistic and strict timeline, always working backward from the date that the client needs a final product in hand. Then we set deadlines for both our design team and for the client. Everyone involved reviews and approves the timeline, always keeping aware of the number of days between each step. That way, if something goes horribly wrong, they know how much time they have to turn things around. Finally, we delegate three crucial roles to team members:

"For me the solutions come easy,

- Timekeeper—monitors the schedule and documents progress (or lack thereof)

- Internal "bad cop"—cracks the whip in-house when we're lagging (often the same person as the timekeeper)

- External "bad cop"—phones the client to tell them they're lagging

In all but the most difficult cases, this process usually keeps us right on track. And, believe it or not, clients love it.

A case in point: a couple of years ago, we began a project with a client who was notorious for missing revision and approval deadlines (but of course was belligerent when the project would take longer than they had originally anticipated). For some crazy reason, I told the client that we always print a full-color, glossy, wall-sized poster with the project timeline on it for the wall of our office, and that this print cost us $426 to produce.

"If we have to adjust the timeline of the project because of deadlines you miss," I told them, "we'll need to produce a new wall-sized poster."

While we were happy to pay for the first one, they would be responsible for the cost of any additional prints that became necessary. They didn't question this and the project got underway. By the time we finished, we'd billed the client for $2130 of unnecessary wall posters.

And they never said a word.

Tough to say, but perhaps one of my shining moments as a design firm principal—and a lesson for a client that time truly is money.

—Pash, Digital Soup,
Culver City, CA

it's the people who are the work."

—Jackie Merri Meyer,
Warner Books, New York, NY

> Suddenly the door opened and a tiny man stepped in. "Good evening, Mistress Miller," he said. "Why are you sobbing so?" "Oh," the girl cried, "I must spin this straw into gold and I don't know how!"

—Rumpelstiltskin, from The Brothers Grimm

If designers are represented at all in the world of fairy tales, they're most aptly portrayed in the story of Rumpelstiltskin. In this tale, our heroine is shut in a room filled with straw, given a spinning wheel and a tight deadline, and told to spin the straw into gold. Sound familiar? As a designer, you've often been given a tiny budget, few resources and little support, but expected to achieve similarly miraculous results.

Most of the day-to-day decisions you make as a designer involve money—or more accurately, the lack of it. Your creativity is applied not only to producing great design concepts that work but to stretching project dollars to the limit to achieve the best results you can for your clients.

Our fairy-tale heroine was forced to rely on a short, ugly man to create her miracles, but you don't have to. In this chapter, you'll tap into the experiences of other designers who have been there, spun that—and in the following pages, share their trade secrets to making the most of "straw" budgets.

MONEY MATTERS

MATTERS

TRADE SECRETS TO MAKING THE BUDGET

Use New Product Samples to Create Unique Solutions

With some imagination, gadgets can provide cheap-but-creative fixes

We were just finishing up a $15,000 multimedia CD media kit for one of our magazine clients. The project had already gone over budget for various reasons. Just before we were to send the project to the duplicator/printer, the client informed us they were launching a new magazine and wanted to include it in the multimedia part of the CD. I informed them that doing so at this stage would double the bill.

The client couldn't spend any more on the media kit, according to the budget and the final word from the boss, so I proposed that the new magazine should have its own launch budget. The client came back with a $4,000 budget. Glad to hear it, but 4K? For a magazine launch?

One of my vendors had recently brought me a sample of a mailer tube that makes a sound as the end cap is removed. We comped up a quick little insert that attached to the sound cap and sent the sample to the client. They loved it. We ended up printing the insert in-house, had it folded by a vendor, printed Avery labels at a quick-copy store and inserted the flyers and end caps at the office—all within two weeks and at a cost of $4,068.

—Gary Unger,
Graphics Crisis? Call Gary!, Atlanta, GA

Discover Cheap Artwork
in Unexpected Places

To meet the budget, think outside the box

Stock or copyright-free photography is not your only option if you're looking for low-budget artwork. Think outside the box and consider repurposing some unconventional sources:

- Scan contact proofs; the filmstrip edges add interest

- Purchase outtakes from a professional photographer who specializes in the subject you need artwork for

- Contact universities, chambers of commerce, historical societies, zoos, newspapers, government agencies and tourism bureaus and inquire about the availability of free images (note: this will take some time)

- Check your own snapshot albums for images. If a photo isn't perfect for your project, maybe you can manipulate it to serve your needs

- Rediscover clip art. Colorize black-and-white clip art or combine several pieces to create a new composition

- Explore dingbat fonts. They can be a great starting point. Pull the images into a drawing program and start experimenting and adding your own colors

—Adapted with permission from Designer's Survival Manual, HOW Design Books 2001, by P. Evans; and Bill McDonnell Graphic Design, Philadelphia, PA

Put Online Job Banks to Work for You

Is work slowing down and you'd like to take on new clients? Online job banks have become an increasingly popular marketing tool for designers. And several of them focus exclusively on designers, web professionals and other creatives, matching your skills with a vast network of potential corporate clients.

Some online job banks offer free resume postings, and some even offer free portfolios. More elaborate services, ranging from multi-image portfolios to animated presentations, are offered on a fee basis. But the Internet is a huge pond, and it's easy for designers to get lost in the shuffle if their portfolios aren't visually arresting. To make sure your portfolio stands out on the virtual landscape, follow these tips:

- Consider developing your own web site. Many online job banks will link to your site, so you can lure them into your own corner of the web for more information.

- When creating your online portfolio, never post text only and hope viewers will link to your web site for the pretty pictures. If there are no images, the busy design buyer will pass you up and click to the next portfolio.

- Change your portfolio samples frequently. Change, or at least shuffle, images every two months.

- Highlight your signature style. When choosing images, stick with one or two styles you do best. If you throw in every visual but the kitchen sink, viewers won't get a quick sense of your style. You can always show new styles next time you update.

- Consider showing detail shots of strong images rather than the full image. Buyers' initial view of your images will be in thumbnail size. Complex images don't reduce well, so show details of an interesting overall image instead.

- Title your sample and provide enough description to let viewers know what it's about and why it was created.

- When providing biographical information, give viewers some insight into your personality. Anecdotes are more interesting than a dry litany of facts and client lists.

—Adapted with permission from "Why Go It Alone?" HOW magazine, April 2001, by P. M. Knapp

Save on Envelope Costs

Use standard sizes to simplify and save money

Thinking ahead about the size and type of envelopes you'll need for your project can be a significant money-saver. Follow these tips to simplify your project and save:

- To avoid the cost of expensive custom envelopes, design your work to fit standard envelope sizes. Sometimes the difference between a standard envelope size and a custom-printed envelope is quite subtle physically, but not monetarily.

- To add punch to your mailed pieces, consider using colored standard envelopes. They stand out dramatically among all the white envelopes in the mail.

- When a project involves multiple pieces to be sent at intervals, plan ahead. If the sizes of the pieces are similar, design them so they can each fit inside the same standard-size envelope. This may allow you to take advantage of volume pricing.

—Bill McDonnell,
Bill McDonnell Graphic Design,
Philadelphia, PA

Use these standard envelope sizes to help you save costs before you begin designing. You may find a standard envelope that is close in size to the piece you are designing, but far more affordable.

1- 4.375" x 5.75"
2- 4.25" x 6.5"
3- 5.25" x 7.25"

4- 3.625" x 6.5"
5- 3.875" x 7.5"
6- 4.125" x 9.5"

Print "Sheetwise"
to Add (Free) Extra Color

This printing technique provides three colors for the price of two

If you're printing a design on a sheet-fed press, you can set up the job in two basic ways.

Method one: The printer can print all of the pages of the signature on one side of the paper, then, when it's dry, turn the sheet over from left to right and print the same set of pages on the other side. When the job is completed, Page 1 is backed by Page 2, Page 3 is backed by Page 4, etc. This method is called "work and turn."

Method two: The printer can print half of the pages on one side of the sheet, turn the sheet over and print the other half of the pages on the other side. Both methods produce the same number of finished pages printed on two sides. But if your printer uses this "sheetwise" method, you can increase the apparent number of colors used in your job by changing the ink fountains to print the back side of the sheet. So if you're printing a two-color job, you can print one side of the sheet in black and red, for example, and the other side of the sheet in black and yellow (or any other two colors you want). You'll still be charged for a two-color job, because you'll only use two ink fountains.

—Excerpted with permission from "Press Check," HOW magazine, February 2001, by Constance J. Sidles

Collect on your Creativity

My greatest fear is any job that takes longer to collect the money owed than it did to do the job. I once had a client who was months behind paying me. I had the boxes I'd designed printed, the item manufactured and imported and distributed, but he still hadn't paid me. He finally settled with me the morning we were going to small claims court, but I still had to send him two to four notices every month to collect the monthly $100 payment he agreed to...and it took years to collect. He'd promised to give me payments along the way, but they never materialized and I just carried on with the work.

Solution: be sure to get payments at every stage ($\frac{1}{3}$ up front, $\frac{1}{3}$ halfway through, $\frac{1}{3}$ at the finish is my norm), even if it is a friend or relative. That way, the worst that can happen is that you only get stiffed $\frac{1}{3}$ of the total amount agreed.

—Jill Bell,
Jill Bell Design and Lettering,
El Segundo, CA

Use the Right Sheet Size to Save Money

You wouldn't think so, but in many cases, using a slightly larger sheet than necessary has a tremendous impact on the price of paper used for your job. Make sure your printer uses a sheet size that makes sense for the job, and ask if your specs can be adjusted slightly to save paper. (Reducing sheet size also reduces weight and saves on postage.)

Here's an enlightening look at how going up just one sheet size can blow your budget:*

SHEET SIZE	PRICE	PRICE INCREASE
19x25	base price	
20x26	base price x 1.1	(10% higher than 19x25)
23x29**	base price x 1.4	(28% higher than 20x26)
23x35	base price x 1.69	(21% higher than 23x29; 55% higher than 20x26)
25x38	base price x 2	(18% higher than 23x35)
26x40	base price x 2.19	(9.4% higher than 25x38)
28x40	base price x 2.34	(8% higher than 26x40)

*Factors based on M weights of same dull-coated cover-weight stock
**Rarer sheet size

—Jackie Cuneo,
Watermark Graphics, San Francisco, CA

Create the Look of Premium Papers on the Cheap

Add high-impact effects for less money

With these on-press tricks, you can save money by using less expensive paper, but achieve close to the same effects as you would using expensive premium stock:

- Use a #2 sheet with an aqueous coating to achieve a #1 finish. The aqueous coating adds a heavier finish to the sheet.

- Produce an ivory sheet by printing a 3% to 5% screen of yellow on white paper.

- Enhance a less-expensive sheet by using a PMS color to add a texture or pattern to the background.

—Savage Design Group Inc.,
Houston, TX

"Clients often want a Spago meal on a McDonald's budget... maybe I can at least give them Denny's."

—Jill Bell,
Jill Bell Design and Lettering, El Segundo, CA

Produce It Yourself
and Beat the Budget

With a little help from your
friends, family and coworkers

To keep costs down or meet tight deadlines,
enlist the aid of coworkers, friends, family and
even clients to help produce pieces (depending
on the size and scope of the project, of course).
I've designed pieces that require hand cutting,
unusual bindery solutions, assembly, etc., and
often the budget does not permit the costs of
outsourcing these tasks. So, with the help of
supportive friends, family, clients and others, the
pieces are produced for as little as the cost of a
few pizzas. Everyone involved seems to enjoy
being part of the production and revels in the
moment when the final product is complete.

—Cheryl Roder-Quill,
angryporcupine, Cupertino, CA

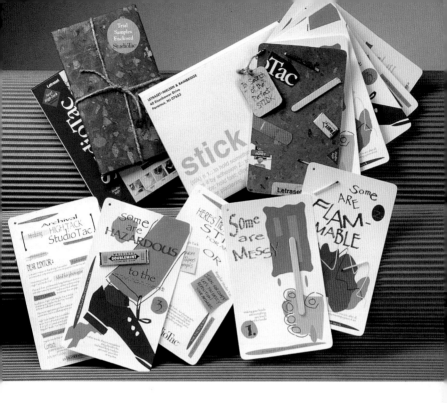

Sunspots Creative (Hoboken, NJ) assembled each piece by hand in these Studiotac 3-D brochures (including lighting and blowing out each match for safety reasons). The result: they created a visual impact that could not be duplicated by a manufacturing process.

It's All in the Timing

If a job has a ceiling or is a flat fee (most at least have a ceiling) start warning your client as soon as you can tell it is exceeding your expected time frame. Depending on their response, keep very good time and expense records (if they say the increase in time and expenses is fine) or start looking for places where you can cut corners.

You'll definitely learn from your mistakes. Earn minimum wage for just one job because of an exceeded time frame and the next time a similar job presents itself the red flag will immediately go up and you'll charge more and set clear conditions.

—Jill Bell,
Jill Bell Design and Lettering, El Segundo, CA

"Good design will always come to the foreground regardless of the size of the budget—but designing responsibly and appropriately is one of the most important things to keep in mind."

—Elaine Cantwell,
spark, Hollywood, CA

Proofreed, Proofreed, Proofreed

Of course the need to proofread is a no-brainer. But surprisingly, many designers skip the basic step of proofreading and pay for it later—in time and money. Have more than one set of eyes (preferably three) read the copy on your job. Spellcheck finds misspellings, but it won't change badly worded copy, correct proper names or add in the word you accidentally omitted. Make sure the dictionary in the software program you are using is kept updated with terms in your style guide.

You get what you pay for: Shell out the $40 per hour for an experienced proofreader and save yourself money in the long run. Here's how expensive that lesson can be:

- New laser proof, per page: 3 cents

- New dye sublimation proof at your studio: $1 to $5

- New blueline proof at the printer, per page: $15, plus file review and changes ($100 to $200 per hour)

- New contact color proof, per page: $100 to $200, plus file review and changes ($100 to $200 per hour)

—Jackie Cuneo,
Watermark Graphics, San Francisco, CA

Use Existing or Standard Die Cuts

If you communicate with your printer in the early stages of a project, you may discover that he has existing or standard dies on hand that will suit your needs. By using an existing die, you can save significantly. For example, you may want a folder with a 6" rounded pocket. But the 5" rounded pocket die your printer already has on hand is close enough to satisfy you and give your budget a break.

Communicating with your printer is the key. If you have the time to go over the layout of the job with them, they may have suggestions pertaining to the size of the piece, existing dies or color suggestions, or tweaks that will enhance the project and help you save money and time.

—Savage Design Group Inc.,
Houston, TX

Use Client's Trim Space for Your Promo Pieces

"Wasted" space is valuable real estate

My self-promotional business card is accordion-folded five times; it includes images of my work as well as client testimonials. I printed it on the "wasted space" edge of a client's quarterly newsletter. I've also printed business cards on the edge of a run of pocket folders. Even a couple of inches of trim space is enough for business cards, rolodex cards or gift/price tags.

—Lisa Fiedler
Jaworski,
Fiedler Designhaus,
Finksburg, MD

Create a "Distressed" Look, Cheap and Easy

For background imagery or type, think dirty and crumpled

Here's an easy, cheap way I've discovered to create a distressed background or custom-type solution. Just print the image out at 100%, then enlarge it on a photocopier. (If the copier is blotchy or dirty, then BONUS! You'll get better results.) Crumple up the page until the ink starts to break apart, then enlarge it again. Repeat the process until you achieve the desired effect. Then place the final artwork on your scanner, scan in the image, and manipulate it in Photoshop. A super-duper cost-saving technique!

—Cheryl Roder-Quill,
Angryporcupine, Cupertino, CA

Ronnie Garver created this poster for Las Cruces Museum of Natural History. He found some images he wanted to use, but they were too small, so he enlarged them on a copier, creating the overexposed, exaggerated halftone look.

DIA DE LOS MUERTOS

DAY OF THE DEAD

Win the Paper Chase

Since paper is a major expense in any print-based project, it also provides many opportunities for saving money. Any savings you can realize in either the size of the sheet you specify or the basis weight (overall pounds used) can cut costs significantly. Here are a few tips for saving on paper:

- Use house stock. When requesting a print bid, specify your paper of choice and the "house equivalent." Printers negotiate volume discounts on commonly used stock and often pass the savings on to you if you're willing to use the paper they purchase in bulk.

- Watch out for papers sold by the carton. Many premium papers must be purchased in full cartons. On short runs or jobs using very expensive stock, this can be a budget buster. Ask your rep to recommend a paper that's purchased by weight instead of by the carton.

- Use the most efficient sheet sizes. Sometimes using a slightly larger sheet has a tremendous impact on the price of paper used for your job (see page 54). Ask your printer if your job's specs can be adjusted slightly to save paper. Reducing sheet size also reduces weight and saves on postage, another major expense.

- Minimize overruns. In very low-budget situations, you probably can't afford to print more pieces than you need. Slight overruns are common, but avoid more dramatic overruns and you'll save paper and money. Pay attention to the "overs" line in your print quote (this is the amount of "overs" you agree to buy). The industry standard is five to ten percent, but you can request a lower percentage if you're willing to risk "unders."

- Use discontinued/discounted papers. Work with your print rep—many paper merchants have paper on the warehouse floor that they need to get rid of. If it's near inventory time, they may be more eager to give you a discount.

- Consider custom sheeting. With enough advance notice, paper mills and even your local distributor can cut paper to size for your project. This is a great way to save money without changing your layout to fit standard sheet sizes. Ask your print rep about minimum poundage requirements (usually 5,000 pounds from a mill, sometimes as low as 2,000 pounds from a paper merchant) and how much time is required.

—Jackie Cuneo, Watermark Graphics, San Francisco, CA; and Savage Design Group, Houston, TX

Perfect the Art of Begging

I once worked with a chain of trendy gyms called Crunch. This client loved creative ideas but liked to keep their ad budget small. Take their "Inspirational Workout" campaign, which called for five posters. The client would have been satisfied using the marker comps I had quickly drawn up to show the idea; they weren't convinced that a real illustrator was necessary. After a lot of searching, I found a good illustrator willing to work in exchange for a bit of cash, a credit line and free gym membership.

Then came the "No Judgements" poster campaign, which involved three photo shoots, lots of models and, again, very little money. We found a photographer who would work for a credit and gym memberships for his crew. The models were volunteers—Crunch employees and a few of my coworkers. The makeup and clothing came from the models and from my closet.

The next challenge was a television commercial. The idea was simple, but seemed impossible to execute on our budget of $8,000. We convinced a friend to be the director of photography. My creative director volunteered to direct the spot, and the agency's creative manager did hair and makeup. I ended up as the art director, stylist, production assistant and janitor. The agency president's assistant was the actor, and our sound guy did the voice-over. Most of the props and supplies came from my apartment and from coworkers.

—Sandra Scher,
Oasis, New York, NY

Add Pop on Press

Use these techniques to add color and impact

Hundreds of tricks help you to add eye-popping impact to your project without adding a lot of extra cost. Here are a few pointers:

- Use fluorescent ink in process color for pop on uncoated paper.

- Print cyan and magenta underneath black to achieve a deeper black.

- Substitute PMS 116 for process yellow to create readable yellow text or a large, solid area without adding a separate PMS. A good, rich yellow is difficult to achieve with process colors alone.

- Maximize split fountains. Depending on the effect you want, you can put several ink colors into a fountain, achieving a multicolor project with a single piece of film.

—Savage Design Group Inc.,
Houston, TX

"Basic design principles can help maximize impact when budgets are small: emphasize contrast (in size or color), repetition, or make strong use of color."

—Willie Baronet,
GroupBaronet, Dallas, TX

Choose Black and White
for a Low-Cost, Elegant Solution

With a unique twist, simple is always good

When friends in the band Patrick's Head asked him to create a package for their new CD, Philadelphia designer Bill McDonnell agreed to provide his design skills gratis. But there were still production costs, and the band was on a bare-bones budget.

The band's lead vocalist wanted the design to incorporate photos he had taken of his black dog cavorting in the snow. So McDonnell composed the cover using one of the photos, as well as a type treatment for the band name and title.

He initially left the photo as a black-and-white gray-scale image, but quickly realized that since the covers would be printed on different copiers and printers at different times, he needed to make image consistency as built-in as possible. After experimenting with the image contrast, he converted it to a bit-map mezzotint using a diffusion pattern. This created an image composed entirely of black dots. He used other photos of the dog to create the tray card and disc label, both with the same mezzotint.

Total production costs, including the costs of jewel cases, inserts and labels, color copying and CD production, were $188.20. When the band needs more CD covers, they simply take the files to the local copy center and run as many as they need. McDonnell says the CD packaging and posters far exceeded the band's expectations. "This project proves that good design can exist even on the smallest of budgets," he says.

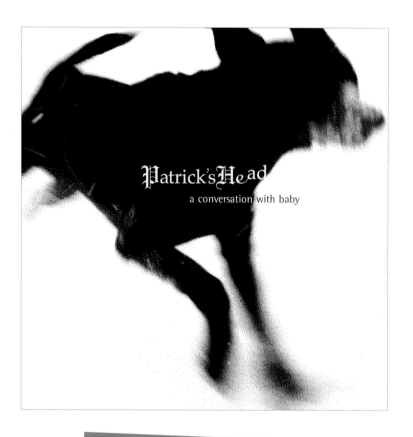

Patrick's Head

a conversation with baby

To produce this dramatic cover design for the band Patrick's Head, Bill McDonnell Graphic Design (Philadelphia, PA) converted a gray-scale image to a bit-map mezzotint using a diffusion pattern. This created an image composed entirely of black dots (no gray) and produced an interesting pattern in the areas where the dog's paws were caught in action.

Use Large Print Houses to Best Advantage

Their economies of scale help you beat the budget

You can save dramatically on print costs by farming your four-color process printing to large four-color print houses. These national print/direct-mail outfits work within limited formats (such as postcard size, $8\frac{1}{2}$" x 11" or 11" x 17") and gang your job with many others, cutting printing costs significantly in many cases.

This approach won't work for all of your projects, of course, but it can be a huge cost-saver if you take advantage of these printers' strengths and are selective about which projects you send to them. Following are some guidelines for using these format print houses:

- Know who's out there. Identify several print houses and categorize them by format, print sizes and services. You can locate many of these companies on the Internet (use keywords "4-color printing" or "digital printing").

- Ask for samples and references. Review multiple samples of their work and check their references directly.

- Be selective about which jobs you farm out to them. These printers are not ideal for one-, two- or three-color jobs. Price wise, they are extremely competitive for small four-color runs and small or large catalogs. (You can also double your bang for the buck by ganging your run within their large gang runs. For example, run two clients' four-color process jobs on an 11" x 17" sheet, then cut them apart.)

- Make sure you have enough time. Dramatic cost savings are the upside of working with these companies. Slow turnaround is sometimes the downside. Know up front how using these companies will affect your schedule.

- Realize that you're sacrificing some control. In most cases, these companies work straight from your electronic files. You also won't be able to be present for a press check.

- Be aware of paper limitations. With most large print houses, you're limited to their house stock, which is typically 80# or 100# gloss coated white text or 80# or 100# gloss coated white cover stock.

- Know their strengths and weaknesses. If you look at enough of their samples, you'll be able to identify what these printers do well and not so well. Perhaps they run inks too light or can't handle rasterized images well. (Your flood-coated print jobs may not stand up to the thin inks. Most companies offer a free flood varnish to protect these types of jobs.) Knowing the printer's strengths and weaknesses will help you better prepare your artwork to compensate.

—Denise Kalmus,
Envoi Design Inc., Cincinnati, OH

Stock photography, illustration and the digital age have expanded our creative freedom to give projects with limited funds that million-dollar look.

—Jackie Merri Meyer,
Warner Books, New York, NY

Overprint to Create Two Pieces from One

Double your impact and lower costs by using one piece as a springboard for the next

Strong Current, a modern dance company in San Francisco, hired us to design a poster and a direct-mail piece for some upcoming performances. They had only $600 to spend on production costs, so we needed to design the pieces to work together, while maximizing our press run. Our solution was to create a two-color poster, then overprint black on the front and back to create four distinct postcards for direct mailing. The postcards—each a quadrant of the poster with black overprinting—are distinct but maintain the experimental, dramatic qualities of the poster.

Our budget went like this: a two-color job on colored paper for $200; printing of 1,000 posters for $300; and overprinting of 500 posters with black ink on both sides for $60. The result was 500 posters and 2,000 postcards for $560.

—Blake Trabulsi,
Zócalo Design, Austin, TX

With only $600 to produce 1,000 posters and 2,000 self-mailing postcards, Blake Trabulsi, Zócalo Design (Austin, TX), created a two-color poster, then over-printed it in black and cut it into postcards.

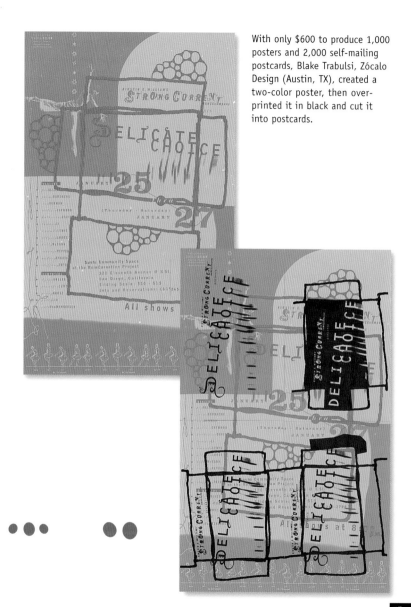

Consider Service When Choosing Printers

Print bids can be misleading; it's not all about the bottom line

The way your printer estimates your job can have a huge impact on your final price. Instead of focusing on the lowest final bid, make sure you understand exactly what you'll be getting for your money. Review the bids of potential printers thoroughly with your potential printers. By estimating the job efficiently, you may be able to purchase the same print job from your favorite high quality shop for close to the same price you'd get at the budget shop down the street.

Keep service in mind as you choose vendors. An attentive rep can save you many headaches by acting as your advocate in the plant while your job is in progress.

Your billable time is much better spent meeting with clients or finishing designs than babysitting inattentive vendors.

—Jackie Cuneo,
Watermark Graphics, San Francisco, CA

"I spend the client's money as if it was my own. I am fair and frugal, but generous when needed."

—Jackie Merri Meyer,
Warner Books, New York, NY

74

Use Duotones as a Versatile Color Solution

Save money and add countless design possibilities

If you want to use a photo but are limited to, say, two PMS colors, create a duotone out of the photo. In Photoshop, convert the image to gray scale. Then pull down to Monotone and choose your option. By choosing "Custom" you can create a duotone with the exact PMS colors you need. Another tip: Reverse the direction in your curves so you create a true duotone. Most people leave the curves in the same direction, which creates an overlapping of the color at the same percentages and in turn, produces a really muddy image. By playing with the curves, you have more and better color control and can create some really incredible variations.

—Linda Athans,
Athansdesign, Clearwater, FL

Less is More When Designing Multiple Pieces

Combining pieces on one sheet can save your budget

Like many private schools, Notre Dame Catholic Schools in Portsmouth, Ohio, holds an annual fundraiser to supply money for projects that don't fit into the regular school budgets. Therefore, the money they needed to produce a brochure for the annual fund didn't even exist yet—talk about constraints! My mission was to design and print a six-piece mailer—4,000 brochures, pledge cards, information cards, return envelopes, letters and mailing envelopes—for as little as possible.

I offered to design the project for free, then tried to find a printer on the same brain wave (no such luck). Next, I set out to use as little paper as possible. I began sketching on a piece of 8½" x 14" paper (which, when folded, is small enough to use as a standard-size self-mailer). I combined the pledge and information cards first, then finally came up with a way to squeeze the brochure and letter all onto the same sheet. Since the recipients would need to write on the pledge and information cards, the project called for nonglossy paper (less expensive), but as a mailer, the piece still needed to be substantial.

The final quote was $282, which included paper, the negative, folding and perforation. Study-hall students folded the return envelopes. Final result: I saved big by reducing the six-piece mailing down to two pieces.

—Kristie Johnson,
Turnergraphics, Lucasville, OH

Print Isn't the Only Option

Using new media might be the answer for a client who has to curb expenses

If your client has a big catalog, huge brochure, or simply a lot to convey, but doesn't have the budget—maybe you should look at putting it on a CD-ROM. Depending on how large the printed document would be, it may be cheaper to produce CDs complete with custom packaging and silk-screened printing.

Working in Director or Flash is our preferred way to create CD-ROMs for our clients. But, depending on the audience, it could be just a collection of PDF files.

—Randel Gunter,
Gunter Advertising, Madison, WI

Use Premium Papers to Elevate Low-Budget Projects

Paper adds versatility and color, especially to short-run jobs

Premium papers elevate even the most humble small-budget projects. Consider the following ways to use paper for maximum creative effect:

Duplex paper (paper that is a different color and texture on each side) can create the effect of a two-color job, even if you only use one ink color. Consider using duplex paper for business cards and announcements. The print job can be run on each side of the paper simply by turning over the paper during the press run. This is still a single-sided job but with two different appearances in the end.

Flecked or "confetti" paper creates a multicolor look for one- or two-color projects.

Vellum papers add elegance and a high-cost look to applications such as announcements, business cards and invitations. They also come in multiple weights.

Synthetic papers are cost effective for applications (such as menus) that might otherwise require lamination. Many white synthetics look and feel just like paper but can be wiped clean. Some come in colors. Most synthetics are unrippable but require special inks.

Colored papers, especially creative combinations of them, add life to one-color jobs. For example, create a beautiful look using a PMS metallic color on a dark-colored or textured paper. When designing multiple-piece projects, mix coordinating paper stocks for added versatility. And don't forget that flood-coating your design allows you to see the paper come through and add lots of contrast. You may wish to run part of the job reversed out.

—Denise Kalmus,
Envoi Design Inc., Cincinnati, OH

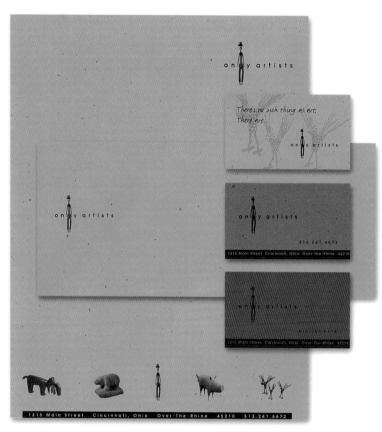

Used creatively, premium papers can elevate even the lowest-budget job. Envoi Design (Cincinnati, OH) added punch to an identity system for Only Artists using complementary colors of a premium stock.

Negotiate a Paper Mill Buy-In

Promote yourself, the printer and the mill in this triple-win situation

Leverage your design reputation by negotiating with paper mills to help pay for unique projects. What's in it for the paper company? Free design of a great promotional piece. What's in it for the printing company? Great exposure. The printer entrusted with a major mill's promotional piece has the opportunity to reach a wide audience with a great sample of their work. And what's in it for you, the designer? A design credit on a major mill's hottest papers can put your design firm on the map (or keep it there). Often paper companies will mail or hand distribute thousands of promotions to printers and corporate print departments.

Negotiating a buy-in can be a great way to reduce costs per piece and keep the job profitable while pleasing everyone involved. Costs (and savings) can be shared by the printer, designer and paper company, giving all three the most financial benefits for their efforts.

A PROJECT IS A GOOD CANDIDATE FOR A MILL PROMOTION IF IT...

- uses two or more colors, weights or brands of paper from the same mill

- effectively showcases the papers' printing properties, yet leaves enough white space to highlight the papers' brightness and texture

- demonstrates creative use of paper combinations, special finishing or binding techniques to pique interest and persuade potential customers to select the stock for their next job

- incorporates content and design that are relevant, timely or "hot" for the current season

—Jackie Cuneo,
Watermark Graphics, San Francisco, CA

Use Existing System Fonts

Save money by avoiding expensive font purchases

Consider the impact of font purchases on your total budget. Existing system fonts—those that come preinstalled on Windows-compatible PCs—are free, while special fonts may cost your client thousands of dollars. Particularly when you're building a branding campaign, using existing fonts on everyday materials such as stationery, forms and fax sheets results in significant savings, because when you choose a special font, your client will have to purchase the font for every user of the materials. The larger the client, the higher the costs.

While you may consider system font choices somewhat limited compared to the thousands of fonts available on the market, by using them, you'll save money as well as the time it takes to distribute the purchased fonts. Substituting Times Roman (system font) for something like Garamond (nonsystem font) may affect your design slightly but is a fiscally responsible choice for your client. Brand-critical fonts, such as those used in a logo or header, can be converted to artwork to ensure consistency.

—Savage Design Group Inc.,
Houston, TX

The Currency of Respect

If you're uncomfortable "talking cash" with clients, it's a sign that you're not confident in the value of what you do, and this will seep out to clients through all kinds of cracks. Money is the currency of respect, and any real client does not need you to subsidize them, and certainly won't listen to you if you don't charge confidently.

Track their time and then spot check a job against time estimated versus time spent (in hours). Timekeeping is not designed to control how much time you spend on this job, but to help you provide a better estimate next time.

—David C. Baker,
ReCourses Inc., Nashville, TN

"As someone once told me, you are only as good as your last job."

—Gerard Huerta,
Gerard Huerta Design Inc., Southport, CT

Create Your Own Stock Library

Arm yourself with low-budget image alternatives

Through the years I've come to realize the importance of having a large library of images at my disposal at all times. Because many projects are constrained by low budgets, stock photo images are often too expensive to use. So I've built my own image library by carrying my camera with me at all times. While I don't claim to be a professional photographer, programs like Photoshop and Adobe prove I don't really need to be.

For example, while I was photographing some friends at a park last summer, I took a few extra shots of some kids skateboarding. A few months later I was asked to design a quick, inexpensive logo for a local clothing company called Stick Skatewear. After shopping some stock image houses and deciding the photos were either too "stock" or too expensive, I scanned one of my photos, clipped around one of the skateboarders, eliminated the background, darkened the photo to black, transformed it to a bit-map image, changed the color, altered the angle and size, and BAM! I had created a great two-color logo that looks like line art and can be produced for letterhead, tee shirts, stickers, business cards, caps and other merchandise. The client loved it and was thrilled that the job didn't cost them a huge amount of money. I've since done this with at least a dozen other "homemade" stock photos from my personal collection.

—Jeff Schaller,
Schaller Image & Design, Buffalo, NY

84

Follow this Rule of
Thumb for Spec'ing Color

Here's how to decide between Pantone and process color

In the case of color constraints, I use a simple rule of thumb: three colors or less, spec Pantone. More than three colors, build them from CMYK. This has proven very cost effective for printing.

—Linda Athans,
Athansdesign, Clearwater, FL

This art by Jim Krause, author of *Color Index*, is an example of three (left) and four (right) color combinations.

Survive Stormy Weather

When financial times get tough in spite of your best management efforts, it's time to make some difficult decisions about your company. First rule: Act quickly and decisively.

DO

Be honest with your employees. Tell them what's happening and why. Involve them in the process wherever you can.

Cut staff if you have to. Since employee costs are your largest expense, cutting staff or asking for voluntary salary reductions are the quickest ways to dramatically cut expenses. (Rule of thumb: Your salary load should be about 45% of your adjusted gross income.)

Cut expenses. Defer the purchase of new equipment. Cut back on training, education, supplies, travel and perks.

Defer payables. Pay off small obligations, but ask other vendors to turn the total amount you owe them into a loan, with 90 days' deferral followed by monthly payments with interest. If you're honest and outline your plan for payment, they'll probably work with you.

Speed up receivables. Invoice more frequently. Ask for an up-front deposit when you begin a project.

Look for revenues from unexpected sources. Find "hidden" money by subleasing excess office space or selling assets, such as unused computer equipment and office furniture.

Think long term. Don't do anything that alienates clients, negatively impacts your brand image or affects service.

DON'T

Borrow money. Taking on new debt when you can least afford it only prolongs the hard times.

Sign leases. You can't avoid additional fees.

Take on new overhead. It's not a good time to buy new equipment or expand your office space.

Stop marketing. If you're like many companies, you've worked hard to establish a market position. Don't let up.

Factor your receivables. Some companies will give you an advance against receivables. Fees are high, and the companies will ask your clients to pay them directly, which sends an alarming message to clients.

Miss any tax payments. If you don't have money to pay the taxes, you don't have money to pay the substantial penalties that will result.

Lower your prices. Clients assign value on price, and this could send the wrong message.

Jump too quickly to investors. No smart investor will give you money without expecting significant control and may possibly take advantage of your weakened condition.

Panic. Economic downturns are a painful reality but not the end of the world. Only 20% to 30% of companies are severely affected by a recession, and many maintain and even thrive during downturns.

—Adapted with permission from "Stormy Weather," HOW magazine, December 2001, by P. M. Knapp

To Flash or Not to Flash?

The biggest question right now is, "Should I use Flash or not?" In some cases Flash is the right program and in others, HTML makes more sense. With some small web sites—those that do not need daily or hourly updates—Flash is an easier and less expensive option since testing is less time-consuming without all of the font, cross-browser and cross-platform issues of HTML development.

—Savage Design Group Inc.,
Houston, TX

"To make the most of a client's miniscule budget, you need big, memorable, relevant ideas."

—Willie Baronet,
GroupBaronet, Dallas, TX

88

Two-Color Print Tips That Look Great and Won't Put You in the Red

Create an elegant, expensive look with metallics and varnishes

When you're working with a small budget, use metallics and varnishes as your second color. A metallic ink on a glossy stock creates a look and feel that adds an elegance to a two-color print job. Solid areas of metallics build a more expensive look, especially when carried through to other pieces in a family. You can even use metallics on matte stocks—it doesn't give the reflective properties of the gloss, but adds a texture and interest to the piece.

Duotones using metallics also create a very hot look. You can duplicate the look of a silver gelatin-printed photograph by using a black and silver duotone. In Photoshop, play with the curves on the silver so that the pure whites actually print more of the silver color.

You can print a silver photograph as a negative image (invert the entire image in Photoshop), so that when the light hits it, it turns into a positive image much like the old-fashioned glass photographic negative plates. Very cool effect.

One last hint: Always try to have your printer purchase the metallic ink premixed rather than mixing it themselves. Although all the metallics are built on silver, gold and bronze metallics mixed with other inks, it may be tough to match the same color later for subsequent print jobs. It is better to spend that little bit extra and get the color you want in a can so it'll be consistent with the can you get the next time around.

—Randel Gunter,
Gunter Advertising, Madison, WI

Create a MultiColor "Shell" for Newsletters

Printing multicolor blanks saves money in the long run

For two-color or four-color publications, such as newsletters, where black is used for text and accent colors are used consistently on a masthead or other graphic elements from one issue to the next, you can save money by having a large quantity preprinted with just the colored elements. After the print run is completed for the first issue, have your printer pull the blanket on the black and print additional copies with nothing but the accent color. When future issues are ready to be printed, these colored "shells" can then be printed in black with information pertinent to each issue. The result: savings gained from printing these issues as a one-color job versus a two- or four-color job.

—Excerpted with permission from Designer's Survival Manual, HOW Design Books 2001, by P. Evans

Heartland Community Church in West Chester, Ohio, prints out a great quantity of these four-color shells. Then, whenever it is time for a new newsletter to come out, it can be printed with black only to create the finished product.

Recession-Proof Your Company

Business downturns—whether caused by blips on the economic screen, the loss of a major client or the defection of a key employee—are inevitable and threaten the foundations of even the healthiest of design firms. But following these basic business practices can go a long way toward making your company recession-proof:

Market yourself continually. The new-business process needs to happen every day, not just when business slows down.

Create and follow a business plan. Set short- and long-term goals. Develop strategies to achieve those goals, and schedule specific activities that support them.

Stay lean. Keeping overhead down helps keep hourly rates under control and helps avoid layoffs when the work slows down.

Balance your client roster. Make sure that no single client represents more than 25% of your billings. Diversify the types of industries and clients you serve so no one client sector is hit too hard when the economy sours.

Know your clients' businesses. To be a true partner, you must understand their business climate and help them respond to it. Being aware of your clients' business environments also will help you gauge how your clients will fare in a downturn.

Have a financial cushion. Keep several months' overhead on hand, in cash. Aim for at least two months' reserve; more if a single client represents a disproportionate amount of your billings.

Keep your customers happy. The average company loses 15% of its customers every year, so holding on to them equals money in the bank.

Be efficient. Surveys have shown that 20% of hours incurred on client projects are not billable. Avoid this "slippage" to stay profitable.

—Adapted with permission from "Stormy Weather," HOW magazine, December 2001, by P. M. Knapp

Navigate the Peaks and Valleys of Freelance Work

Let staffing agencies help you through the dog days

It's a classic and predictable cycle for freelancers: Business is going great guns for a while, and you're so busy you don't have time to look up, let alone think about promoting yourself to new clients. Then the work slows down, and you're way behind the marketing curve, with no project in sight and no hot prospects waiting in the wings.

Those inevitable peaks and valleys are why many freelancers align themselves with professional staffing agencies. These agencies market you to their established network of potential clients, so you don't have to make cold calls or send out endless mailings. They employ you, so you don't have to mess with unsavory administrative tasks such as quarterly taxes, invoicing or bill collecting. Many even offer benefits, including basic health care and term-life insurance, holiday and vacation pay and even 401(k) investment plans and bonuses.

The downside is probably lower pay. Instead of charging you fees, most staffing agencies charge their corporate clients for your services and make money by marking up the hourly rates. Their profit is the difference between what they pay you and what their clients pay them. But the lower hourly wages may be offset by the fact that they handle taxes, provide benefits and market for you.

HERE ARE A FEW TIPS TO CONSIDER IF YOU SIGN ON WITH AN AGENCY:

- Keep your portfolio updated and ready to show at all times.

- Brush up on your software applications. Agencies need creatives who know the latest applications, so be prepared to be tested on your software skills.

- Know what you're worth. The AIGA (www.aiga.org) has published a salary guide for designers, and you can also network with colleagues and other professional organizations to get a sense of your value in the market.

- Check out the staffing agency's client network. Ask who their corporate clients are and decide if those are the types of clients with whom you'd like to work.

- Be honest and specific with your agent about what kinds of assignments and work environments you want—and do not want—to be involved in.

- If benefits are important to you, do your homework. Some agencies provide a full complement of benefits as soon as you sign on; others require minimum hours of work before benefits kick in.

- Take advantage of any educational or training opportunities the agency provides. If you need training on a particular subject or software, ask your agency representative.

- Stay in touch with your agent. Don't wait for her to call you. If you're working on an assignment you know ends in a week, call to make sure the agency has a new job lined up.

- Make sure the agency you choose specializes in placing designers and other creative professionals.

—Adapted with permission from "Why Go It Alone?"
HOW magazine, April 2001, by P. M. Knapp

Gang Multicolor Print Jobs

Efficient ganging saves money, paper and time

By ganging your print jobs, you can save money (one make-ready versus two), paper (moving up a sheet size to accommodate two jobs reduces overall weight) and time (one set of proofs instead of two). For example, if you have two five-color jobs and four-color process or common PMS colors are part of the equation, these jobs can be run together on the press as a single six-color job. The savings accrued may be significant enough to allow that special print effect or binding technique you thought was out of reach. Remember to compromise on stock finishes and weights so you can run the jobs together. Also, using varnish techniques with open ink fountains allows you to create two different pieces with very different textural qualities.

—Jackie Cuneo,
Watermark Graphics, San Francisco, CA

You can cut printing costs dramatically by using the services of large print houses, which gang multiple jobs on the same press run. They are especially suited to small and large four-color runs. Pictured are several postcard-sized promotions created by Envoi Design (Cincinnati, OH) using these services.

(Painting, top left, by Martine Khadr-van Schoote, Fort Thomas, KY)

YWCA WOMEN'S ART GALLERY PRESENTS

SELECTIONS
from The Woman's Art Club of Cincinnati

Opening Reception – Friday, November 9, 2001 6–8 pm

30'S GALA

SEPT 15, 2001

EXCITING AS ITS TITLE!
The Pretty Petite Woman' and The Tall Thin Man' Get Together in the Most Exciting Wedding Event of the Season!

GLAMOUR WHAT A SHOW!

DRAMATIC DYNAMITE!
A Daring "Finally to Come Wedding" That Pulls No Punches... Startling Stories Crammed Into One... Stories of Love, Greed, Sacrifice, Fear, and Intense Longing... Drawn Into a Furious Whirlwind of Intense Emotion!

LESLIE ANNE FRY
AND
CHRISTOPHER MICHAEL LANNAN

Leslie FRY Chris LANNAN

In The "WEDDING"

30'S GLAMOUR
THINK
COLE PORTER
DUKE OF WINDSOR
JEAN HARLOW
THE GREAT GARBO

THE CARNEGIE CENTER OF COLUMBIA TUSCULUM
3738 EASTERN AVENUE
CINCINNATI, OH 45226
@ 6 O'CLOCK PM

PERIOD DRESS IS NOT REQUIRED BUT WILL BE GREATLY APPRECIATED.

RSVP 351-5917

DESIGN STUDIO
4740 CREEK ROAD
BLUE ASH, OHIO

DESIGN DETAILS INC.

Prevention is the best medicine for late payments

Prevention is your first line of defense. Clearly detailing payment terms in your written agreement with the client should be your first step.

- Negotiate an equitable payment schedule upfront, specifying due dates tied to the completion of tasks. And be sure to document, document, document: Provide your client with copies of proposals, estimates, contracts, schedules, change orders and other relevant paperwork—signed where applicable.

- Many design firms require partial upfront payment—typically a percentage of the total estimated fee for the project. If you decide to implement this strategy, be firm and unapologetic, and enforce it consistently with everyone.

- Before contracting with any client, check out their credit history. During negotiation, ask for at least three credit references, and check them. Also check with the Better Business Bureau and credit-reporting agencies such as Dun & Bradstreet.

- Familiarize yourself with your client's payment policies so you submit invoices in increments acceptable to them. Find out if your client requires a purchase order (PO) to make payment, and read the POs carefully for standards and conditions. Find out if your client has a policy on how soon invoices are paid. This will help you time your invoices wisely.

Pay Up!

The Graphic Artists Guild Handbook on Pricing & Ethical Guidelines, 10th Edition, recommends a step-by-step strategy for collecting payment from clients:

1. At project/task completion, send an invoice stating the amount owed by the agreed-upon date. You may also want to note that a late-payment penalty fee will be applied to overdue balances.

2. If the payment does not arrive in a timely manner, send a follow-up invoice with a handwritten or stamped message such as "Have you forgotten to send your payment?" or "Payment overdue—please remit promptly." Include the late charge if applicable. A self-addressed stamped envelope or your express mail account number may help expedite the payment.

3. If your client does not pay within 10 days of the second invoice, call to remind him or her that the payment is due. This may be the point at which you learn the client has cash flow problems, has a problem with your work or simply forgot to process the payment.

4. If you haven't received payment within 10 days of the phone call, send a "Second Notice" that payment is overdue and expected within 10 days. This notice allows for any human error or red tape that may have caused the delay.

5. If your client hasn't paid up within 10 days of the Second Notice, send a "Final Notice" letter, which should state that unless payment is made within three days, the debt will be turned over to a collection agency, the Graphic Artist Guild's Professional Practices Committee or an attorney.

Now What?

At this point, you've made all reasonable efforts to collect the payment due you, and you've established a paper trail that will help if you end up in court later. Now you have several courses of action to choose from:

Direct negotiation—A phone call or personal visit may be the best way to resolve the problem. Be professional and as unemotional as possible at all times.

Extend payment time—If you believe your client is having a legitimate cash flow problem and you expect payment to come eventually, you may wish to extend the payment time as a professional courtesy.

Last-ditch demand letter—If your client is not responding to phone calls and you've attempted direct negotiation without success, the GAG suggests a demand letter, which should state your demand (immediate payment) and let your client know you plan to pursue legal action if payment is not made.

Graphic Artists Grievance Committee—This service is for GAG members. You must file a grievance and your case must be accepted by the committee before claiming the committee's support.

Mediation and arbitration—Based on the services of an impartial outsider, mediation and arbitration are used for settling disputes outside the courts. They are often much faster and less expensive than suing in court. The American Arbitration Association is available in many cities, or arbitration and mediation may be sponsored by local groups; check your phone book.

Collection services—For fees of between 10% and 50%, commercial collection agencies will do the dirty work for you, continuing to pursue payment through letters, phone calls, visits or legal services.

Small-claims court—The legal system may be your last resort. Small-claims courts give you access to the legal system but are much cheaper and speedier than formal court proceedings. With a little preparation (information is usually provided by the court), you can handle your own case. Each state's small-claims court sets its own limit on the amount of money that can be pursued.

Consulting or hiring an attorney—An attorney may be able to advise you about available resources, your chances for collection and other legal matters. For simple payment-due problems, a general practitioner or collection lawyer will suffice. If the dispute involves control of your artwork, work with someone specializing in art-related law. Discuss fees before requesting or accepting advice. If your income is limited, look into arts-related volunteer law groups.

Suing in civil court—If your case is complex or the amount owed you exceeds small-claims limits, you may have to sue your client in civil court. Consider this a last resort, to be used only after all other alternatives have been exhausted.

"Can't we all just get along?"

—Rodney King

When all's said and done, relationships are what it's all about. Sure, we require (and enjoy) the monetary compensation that work provides, but the human connections we forge with clients, suppliers and colleagues over time are what bring the most value to our work and lives.

Making the most of those human connections is key to succeeding as a design professional. However, as beautiful and rewarding as relationships can be, they are also difficult to develop and harder to nurture. When frustrations develop—either on your end or the client's—your work is affected.

To quote Shawn Parr, CEO of San Diego-based advertising agency Bulldog Drummond, "communication is everything" in client relationships. And bad communication, he adds, is the root of the majority of frustration encountered during client projects.

In this chapter, you'll find plenty of antidotes to client/supplier relationship problems, including tips on communicating through every phase of a project. From learning how to prepare a design brief to talking your way out of a conflict with your printer, you'll find myriad ways to develop and nurture these important connections.

ROCKY
RELATIONS

TECHNIQUES FOR WORKING EFFECTIVELY WITH CLIENTS,
SUPPLIERS AND COLLEAGUES

Repeat After Me:
There are No Difficult Clients

There are no difficult clients.

Clients are the people who pay the bills. That is the bottom line. Clients who seem difficult appear that way due to influences most often beyond their control. Usually, they're dealing with internal pressures, unrealistic goals and impossible deadlines.

The best way to deal with these situations is to stay focused on your client's business problem. If they do not like your solutions, put on your business hat and assist them in finding the right ones. These solutions will not always be portfolio pieces. Find out what the client needs to accomplish to succeed. Partner with them to reach that goal. It's your job to help guide and educate your clients to make solid creative choices. You may not always agree with their choices, but the relationships you build will be your greatest reward in the end.

—Rhonda Conry,
Conry Design, Topanga, CA

"Sharing your true passion with a client sells ten times more than anything else. When a client knows you truly have passion, interest or desire to make their project better they can relax."

—RaShelle S. Westcott,
creativity coach, Newport Beach, CA

Before You Meet Your Client...

If you buy into the rumors, you may end up believing that every client is difficult. Most agencies do a bad job of managing expectations and communicating with their clients. Save yourself time and energy by avoiding these mistakes:

- Don't assume your client is difficult, stupid, stubborn, clueless or all of the above. Clients are people who have a lot to accomplish, with too little time to devote to any one project, and their arses are on the line for results.

- Don't enter a client relationship without understanding the environment and the people you'll work with. It's like flushing money and time down the drain. Great work comes from mutual respect and understanding. It's your responsibility to educate your client on how to produce the best results. If they don't match up or can't work under your terms, you'll know at the front end you're in for a rough ride.

- Don't be too agreeable. Especially at the front end, play a little hard to get. Tell it like it is (with respect and grace) and don't be afraid to walk away from the tough ones.

- Don't involve yourself in a "design by committee" relationship. Design by committee is absolute nonsense. Angle for a single point of approval, or at the very least, understand the approval steps.

—Shawn Parr,
Bulldog Drummond, San Diego, CA

Know Your Client

When hired by ad agencies to do independent design work, I have experienced situations in which I had no direct contact with the client. Often this is because the agency doesn't want its client to know the work is being done outside the firm.

In one case, after receiving the project specifications from the account executive in charge of handling the client, I began work on a logo design. The project dragged on, with the account executive telling me the client simply wasn't happy with the results. I was really amazed, as I'd never experienced such a frustrating project. I finally convinced the ad agency to allow me to meet the client. In our meeting, the woman expressed her frustration at my inability to come up with a satisfactory design and described what she wanted. I reached into my business folder and pulled out one of my first design concepts. She looked stunned and said, "Where did that come from? That's perfect for our new logo." I explained it was one of my initial designs. We discovered the ad agency had been selecting the design concepts they felt the client should see from those I had submitted.

Lesson learned? I decided that I would no longer do contract work for ad agencies or other design firms (except the ad company owned by my sister). Today, if I don't have some form of direct contact with the person who actually makes the decisions on a project, I won't take the job.

—Jeff Fisher,
Jeff Fisher LogoMotives, Portland, OR

Gauge Potential Clients' Design Sense

Just this once, judge a book by its cover

We're told not to judge a book by its cover, but in the case of design clients, it's not a bad place to start. Appearance will tell you a lot about your potential client. How does the client dress? What's on the shelves in his office? What magazines does she read? If aesthetics are important to her, you'll get gentle hints. Don't write him off if he's a little "techy" or messy, but do make sure you understand who you're dealing with.

Ask to go over the clients' existing marketing pieces with them. Understand if your client was involved and how. Ask lots of questions (this gives you a clue about how the client articulates) and give an honest critique (strategic commentary that's direct and constructive), and see how they respond.

—Shawn Parr,
Bulldog Drummond, San Diego, CA

Prepare an Effective Design Brief

A design brief is your project road map. By clearly articulating the task at hand and the desired outcomes, the design brief helps keep you on track and in focus—especially crucial when your project is constrained by a stingy budget or impossible deadlines. A signed brief is your go-ahead to get the design process rolling on the path you and the client have agreed upon. It can also be your (and your client's) touchstone during the project.

There's no set format for a design brief, but most designers agree that good ones should share some similar characteristics. They:

- are brief.

- contain a clear statement of the problem.

- provide background information that affects the problem and the outcomes.

- state goals/desired outcomes.

- include a measuring system for success.

- outline cost factors and constraints.

—Adapted with permission from "Building a Case for Design," HOW magazine, February 2001, by P. M. Knapp

"Achieve impressive results by becoming an investigative reporter and identifying what the client is truly looking for in the design."

—Christine Holton Cashen,
motivational speaker, Dallas, TX

Anticipate the Costs of Dealing with Difficult Clients

Don't forget the "stupidity" factor when building your budget

Sometimes designers accept jobs from clients who they know are going to be difficult. Even though you sense that the client will test every nerve in your body, you tackle the project anyway because you want the experience, or you want to add their name to your client list, or you think the project will result in a fine portfolio piece. When estimating such jobs, I often figure in additional hours as a precaution due to the potential for difficulties with the client. I once jokingly told a friend that I was building in costs for the client being "stupid" in the process of their project—or charging them a "stupidity surcharge." In most cases, I have more than earned the surcharge.

—Jeff Fisher,
Jeff Fisher LogoMotives, Portland, OR

Ask Questions Before You Start the Job

Ensure that solutions are on target, effective and approved as presented

We ask our client contact to gather input from all the client team members (ideally a small group) and, most importantly, to distill the answers into one "official" response.

What do you hope to accomplish with this piece? If you had more time/a bigger budget, would you want to do something instead of, or in addition to, this? Why?

Do you have a Mission Statement or Statement of Purpose? If not, can you sum up in a sentence what you want people to think of the new product and/or your company?

Do you have any competition? Is there a competitor's (item here) you admire? Why? Have you seen any similar work that's in keeping with the spirit of what you envision?

What should we absolutely stay away from? Any pet peeves? What is the most common misconception that you've experienced when describing your plan to others?

Who has provided input on this brief/questionnaire? Who will be responsible for evaluating and approving the concepts and design? Your last two answers should the same.

This approach adds a bit more up-front time to an assignment, but the investment pays off as a project unfolds. By doing our homework first, we arrive at solutions more quickly and accurately. Our designs are typically approved much faster and with few changes, as we have already obtained consensus and managed expectations.

—Alexander Isley,
Alexander Isley Inc., Redding, CT

110

Sell Your Clients on the Value of Design

Let's face it—not all your clients will be the design-savvy Targets and Starbucks of the world, ready to sign million-dollar contracts for design work. More likely, you'll need to educate them about the basic value of design and how it can boost their business. Following are eight ways to educate your clients and communicate design's role in business:

Be a strategic business partner, not a service organization. "When you're a service organization, you're a servant and you're not in charge," says Peter Phillips, a branding and design management consultant and former creative director for Gillette. "Many design firms categorize themselves this way, then wonder why their clients won't listen."

Speak the language of business, not design. Structure your conversations with the client around business situations, not the less-tangible realm of design. Most clients don't want good design, they want growth or profits.

Arm yourself with information. Business publications increasingly cover the importance of design to strategic success. Use the coverage in publications such as *Harvard Business Review, Inc., Fast Company, BusinessWeek, Forbes* and *The Wall Street Journal* as a selling tool. Alert your clients to recent design-related articles in the business press or mainstream media. The Corporate Design Foundation (www.cdf.org) and Design Management Institute (www.dmi.org) web sites are excellent sources also.

Identify your client's problem. Through initial contact with the client, supplemented by some research (the Internet, interviews with customers and industry experts, etc.), develop an informed point of view about his business, competition and other factors that impact success.

Prepare a design brief. A design brief clearly articulates the problem to be addressed and the results being sought. It should include a clear statement of the problem, background information that affects the problem and outcome, goals, a measuring system for success, cost factors and time restraints.

Talk about design as asset management. If your client is reluctant to invest his money in design, provide examples of successful companies that have used design to enhance their market position. The success of companies like Target (see opposite page), Starbucks, FedEx, Coca-Cola and McDonald's demonstrate the worth of brand image and how it can be used to drive the bottom line.

Show results, not just pretty pictures. A great-looking portfolio may not be enough to get you the job. Be ready to talk about the problems each project posed and your business-based approach to solving them.

Stick your neck out. Some design firms put their money where their mouth is by accepting royalties or equity in newly developing companies in lieu of design fees. Such a commitment demonstrates your intention to directly affect your client's bottom line.

—Adapted with permission from "Building a Case for Design," HOW magazine, February 2001, by P. M. Knapp

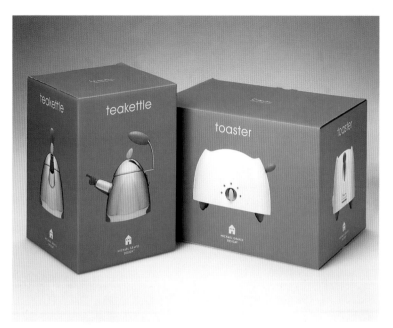

This packaging for the Michael Graves line of products for Target stores shows the store's commitment to visually pleasing merchandising. Design Guys, Inc. (Minneapolis, MN) made sure the product itself would stand out in the busy retail atmosphere.

Everything Old is New Again

Reviewing a list of past problems and solutions might help new projects

One of the first things to do when beginning a project is to review files of projects that share similarities. For each project, create a folder that includes a thorough listing of the problems and solutions to any number of situations that arose throughout the course of that particular project. Check to see which segment of the project took the longest, which suppliers were used and whether their performance met expectations, etc. Reviewing previous projects in this fashion will usually get you in the proper mindset for a new project, and will help you remember the most important issues that will require attending.

—Scott Boylston,
Savannah College of Art and Design,
Savannah, GA

Before You Accept a Job, Ask Questions

What do we know about the client?

- How did the client hear about us?

- Why did they call us in?

- Does the client seem familiar with our work/capabilities?

- Does the client have any concerns or hesitation about our capabilities?

- Who will be providing input on the design brief?

- Who will be the ultimate decision-maker? (Should be the same person who provides input)

- How will the decision be made?

- How experienced is my client contact? Has she done this type of project before?

- How much does the client know about the project?

- What do I know about the client's business?

- How does the client like to be billed? Terms, timing, purchase orders, etc.

What do we know about the assignment?

- What is the challenge?

- What do we hope this project will accomplish?

- Has the client tried something similar in the past?

- What is the schedule?

- What is the budget?

- Who is the competition?

- When is the appropriate time to ask more detailed questions?

—Alexander Isley,
Alexander Isley Inc., Redding, CT

Make Your Client's "Vision" Work for You

Many clients think they're designers. They already have a design in mind when they approach you and they expect you to simply digitally produce what they've sketched on a cocktail napkin. Rather than try to talk them out of their vision, I always create three designs for them: one that's exactly what they wanted, one that I wanted and one that is a compromise. Nine times out of ten, they won't choose what they originally had in mind!

—Linda Athans,
Athansdesign, Clearwater, FL

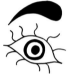

"Make sure people understand what you need by getting them to paraphrase."

—Bob Bapes,
Bapes & Associates, Oak Park, IL

Use Principles of Journalism to Communicate with Clients

At the start of a project, create a clear creative brief to ensure that all parties understand what the crux of the problem or assignment is. This brief should cover the basic journalistic questions of Who, What, When, Where, Why and How. For example...

- Who is the audience?

- What is the client needing to solve and what will the designer deliver?

- When will it be done? (schedule)

- Where can we look for creative ideas?

- Why is this work needed? (audience; state of business affairs; the business opportunity)

- How will it be done or delivered (two comps; three interactive web site links for approval; one FedEx package with one logo, etc.]

The creative brief saves time and energy even on small pieces that appear to be straightforward. Designers aren't always good verbal communicators, so this document lays a good framework for the relationship of all parties.

—Hal Apple,
Hal Apple Design, Manhattan Beach, CA

Avoid Misinterpretation

Be sure to over-communicate if you want to make a project run efficiently. If something can possibly be misinterpreted or misconstrued by either designers or clients, it probably will be. This may sound really basic, but it is critical to get every bit of pertinent information about a project from your client. The level of skill in asking all the right questions is as critical as the skill level in any other part of the process.

The second part of this answer is to communicate all of the information effectively to the team that will be executing the project. Armed with details about the target market, production considerations, budgets, positioning strategy and the color most likely to make the client gag, the designers should be able to deliver solutions that work.

It's ironic that we are in the communications business, and many of us are notorious for our inability to communicate.

—Willie Baronet,
GroupBaronet, Dallas, TX

Attend Client Meetings to Get Firsthand Information

There's no substitute for being there

Rather than passing along meeting results to designers back at the office, we encourage our designers to meet with our clients firsthand. It's important for the people who will actually do the design work to attend client meetings because doing so provides them with insight into the client's personality, preferences and hot buttons.

—Savage Design Group Inc.,
Houston, TX

"Listen, Listen, Listen!

The answers are usually given to us. We are just talking so much we can't hear them."

—RaShelle S. Westcott, creativity coach, Newport Beach, CA

Navigate the Obstacles of Nonprofit Client Work

`Know the unique challenges nonprofits pose`

Nonprofits have fundamentally different organizational styles and decision-making methods than for-profit businesses. While they often have well-defined missions, they often do not have as solid a handle on their audience, branding or objectives as corporate clients. And they typically suffer from lack of resources (money, time, raw materials, people, technology, etc).

To address nonprofits' need for consultation, involvement and consensus, you must bring specific tools to the project: expertise, education and facilitation.

- Expertise is not only the ability to do high-quality work but to explain and defend it in a professional and easy-to-understand way.

- Education is the need to inform the client up front, and at every turn, about the overall process and the specific elements at hand—at the level of detail that's comfortable to them. (Unlike many corporate clients, nonprofits want to know everything about what you are doing and why.)

- Facilitation is the ability to balance different interests and move a conversation forward.

A confident designer with strong talent and these people skills can negotiate the obstacles of working for non-profits to create effective, successful work.

—Day Kirby,
Communicopia Internet Inc., Vancouver, BC

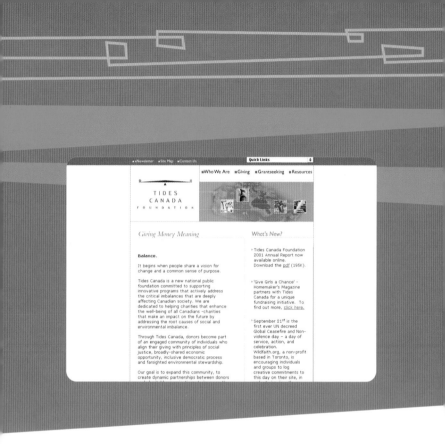

Design for nonprofits demands a high degree of collaboration and intense coordination between the design and client project managers. For the Tides Canada Foundation, Communicopia Internet (Vancouver, BC) developed a web site that balances the interests of the Foundation's audience with those of its varied stakeholders. The site's key feature is a series of Flash accents that flip from grayscale "negative" to full-color "positive" images.

The 12-Step Program for Nonprofits

1. Check your intentions. Why do you want to work for this kind of client? For experience, for charity, to look good or to break into a new market?

2. Don't pick up a nonprofit client "on the side." Make it a business decision. Run the project professionally, and avoid cutting corners. Don't skimp on planning or process because the client isn't corporate.

3. Know the full range of work required and scope it according to your strengths.

4. Identify the organizational structure and group dynamics. How does the organization make decisions? Who is the point person? Normally a project coordinator/manager, an executive director and a board are involved. How do they work together? Who makes recommendations and who makes final decisions?

5. Educate the client before the work begins. Send materials, hold workshops and schedule long phone calls. Have the client do some homework. Try to separate the learning process from the production process, where it will cause confusion and delays.

6. Manage expectations. What must the client have, and what can they cut corners on? Nonprofits often have less resources, so speed is often sacrificed. They should set a realistically long time line for a high-quality project with few resources.

7. Work up to big decisions. Start out by asking the client to make small decisions. Find low-risk ways to show the client the project may be harder than they thought.

8. Avoid project creep. Be explicit about what is and what isn't included in the project. Project creep is particularly hard to manage in projects that stretch over time, as most nonprofit projects do.

9. Get the client team out of the office to do project planning. Make it retreat-like, and an enjoyable experience. Nonprofits are constantly reinventing themselves and are driven by the passion of individuals—there's usually no corporate line to toe—so make scoping meetings a platform for expression.

10. Book more and longer meetings. Nonprofits need extra time for education, expression and decision making. Your client may claim to be able to get through an agenda on time, but have a backup plan if they don't.

11. Mentor the client-side project manager. Educate them so they can lead their team. Since the actual decision makers may not see the work until it is quite advanced, guide the client-side project manager on how to pitch the project so everyone understands how the work addresses the stated objectives.

12. Get sign offs on everything. Make sure the client has actually made decisions when they say they have; get final answers. Use change orders, with consequences attached (usually money or time), if the client wants to go back on their decision.

—Day Kirby,
Communicopia Internet Inc., Vancouver, BC

Educate Your Clients on the Basics of Professional (Web) Design

Or, "Please don't try this at home."

One of the main misconceptions we've encountered with clients is that many don't understand what's involved in professional web design. Some clients seem to believe that anyone with a computer can design a web site, brochure or logo. With all the do-it-yourself software on the market, a professional designer's skills and the time involved in working on a project are often undervalued.

In these cases, we take the time to explain the processes and skills required to turn out a high-end web design project. We stress the importance of the first impression web sites and printed materials make on prospective customers, using the example that a company would not send an unkempt, unprofessional looking person out to sell their products door-to-door. Similarly, a web site must make a strong initial impression. Image does matter, especially in business.

As part of these conversations, we alert our clients to some of the telltale signs of amateur web design, and also emphasize the key aspects of effective web design:

SURE SIGNS THAT A WEB SITE WAS DESIGNED BY AN AMATEUR

- use of unnecessary animation

- bright color schemes that are not pleasing to the eye and lack contrast

- use of unnecessary banner advertisements

- inclusion of unrelated content and/or links

- lack of cross-browser/cross-resolution compatibility and scalability

- omission of text navigation links at the bottom of each page

- inconsistent navigation and/or graphical elements from page to page

THREE KEYS TO EFFECTIVE WEB SITE DESIGN

User-friendliness. Simply put, a user should be able to easily find the desired information. Consistency in placement of navigational elements is the single most important element of user-friendly design. A user should be able to locate navigational buttons in the same places on each page of a web site, allowing him to easily view each page and reach any other page from any place on the site.

Search engine optimization. While no design firm can guarantee placement and/or rankings in search engines, there are ways to ensure optimization for submission, which often results in better ranking. These techniques include unique page titles; ALT tags for images; clear, concise keywords; and descriptive Meta tags.

Marketing tool effectiveness. To optimize your web site's use as a marketing tool, include the URL in all printed material, advertisements, voice-mail greetings, fax cover sheets and e-mail signatures. Your web site should work in concert with other marketing tools to ensure well-rounded promotion.

—Carly Franklin,
CFX Creative, Champlain, NY

Ban Subjectivity from Client Reviews

Set clear ground rules for how work will be discussed and measured

There's nothing worse than hearing completely subjective, personal-preference nonsense during a client's review of your work, especially in a group setting. It's your responsibility to establish clear ground rules at the front end. Don't be afraid to set the tone: Outline criteria and expectations you have of the client to critique your work. Clear expectations and an agreed format for judging the effectiveness of your efforts will give you a platform to defend and preserve smart work.

Outline these expectations in a clear, simple design brief developed by you and the client before the project begins. Agree on who you're building your work for—the 48-year-old marketing executive who has a 13-year-old son who skateboards or the 13-year-old skate rat? Make sure you and the client understand what the audience responds to. Explain that the brief is used to measure your work, remind the client they signed it, and hold them to it.

—Shawn Parr,
Bulldog Drummond, San Diego, CA

Say No to Unrealistic Demands

Let go of your fear of losing business and good things will happen

Many designers, including myself, have driven themselves to the point of exhaustion and illness trying to please clients, mostly out of the fear of losing their business. About ten years ago, I was in this situation with an advertising agency client that represented about 85% of my business. I was working night and day, running between my home office and their agency, not eating properly and getting very little sleep. After several sleepless nights, I finally went to my doctor, who told me my blood pressure had skyrocketed and that, at the age of 35, I was a heart attack waiting to happen. When I explained my client situation, he told me I had to resign the account or end up in the hospital, or worse.

A few days later, I found myself in my client's office relaying the entire story. Having dealt with health issues of her own, she was very understanding. But as I walked out of her office, the real panic set in. What was I going to do for work and income?

The immediate result was my blood pressure dropping almost 50 points within a few weeks. Within two weeks, five new (and more manageable) design clients had dropped from the sky. And I learned the importance of balancing my work and personal life. I established summer office hours of Monday through Thursday, which soon became my year-round schedule. My business is more successful than ever.

—Jeff Fisher,
Jeff Fisher LogoMotives, Portland, OR

Design a Portfolio that Stands out from the Crowd

For design firms, the show-and-tell of portfolio presentation is a crucial part of securing work. But ironically, designers' creativity often seems to lapse when it comes time to package their portfolios.

Not so for Envoi Design Inc., a Cincinnati-based design firm whose unique portfolio makes their work anything but forgettable. The total effect is fun and funky, with a retro/industrial look that catches clients' eyes and piques their interest about what's inside. City Lights Neon, a local industrial design and signage company, fabricated the stylized case, which features clear and orange plexiglass with layers accented by metallic laminates. A rubber handgrip, snaps and blue rubber doorstops are functional and add to the industrial look. Envoi's company name is rendered in routed painted-PVC letters.

Inside the sculpted case, recessed metal-laminate compartments hold a selection of 5" x 8" wire bound presentation booklets geared to different graphic design subjects. Envoi customizes the booklets for each potential client, keeping down costs by generating color prints of their work in-house and using quality paper and corrugated cover stocks left over from other projects. "The booklets are so inexpensive to create that we can leave them behind if we want," says Denise Kalmus, Envoi's president. "That way we can make sure each potential client sees the work that's most applicable to them."

"Our portfolio really represents us," says Steve Weinstein, Envoi's creative director. "Many of our clients are toy companies and nonprofit organizations who see a lot of portfolios. Ours really seems to inspire them and immediately lets them know that we're thinking outside the box."

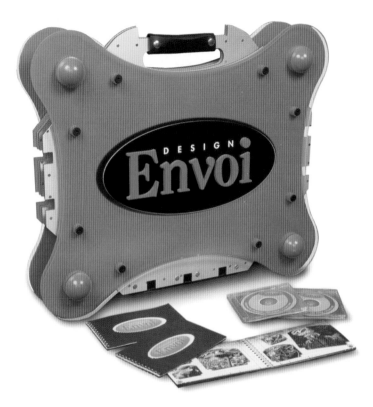

Envoi Design (Cincinnati, OH) designed a funky/retro portfolio case and commissioned a sign fabricator to create it. Clients have raved about the resulting portfolio.

Spot the Problem Client

During my 20-plus years as a designer, I've often been in situations where a little voice inside my head has told me to run for the hills instead of taking on a client's project. After years of taking these jobs, then kicking myself later when they turned into the nightmares I had envisioned, I've finally learned to heed the warning signs.

My turning point involved an educational client who contacted me to create a new identity and marketing materials. At the time, my schedule was very busy, but the client repeatedly rescheduled our meeting so that the organization's executive director could be involved. Finally the meeting day arrived. I met the people involved (including the executive director) and began my presentation. The entire time I was talking to the group, the executive director leafed through a magazine, not the least bit interested in what I had to say. At one point I asked those in the meeting who I would be contacting for feedback on the project. I was told my contacts would be the marketing director and the executive director. The woman didn't even look up from her magazine while being discussed.

As the meeting came to an end, the marketing director asked if I would like to proceed with the project. I was stunned when I heard myself saying, "I don't think I'm the right designer for your project." When she asked why, I surprised myself further by adding, "I rearranged my busy schedule three times so the executive director could attend this meeting, and she has spent the entire

time reading a magazine. If she is one of my primary contacts, I seriously question my ability to work effectively on this project." Later, the executive director apologized profusely and asked me repeatedly to take on the project, but I stuck with my gut instinct. The project was taken on by another designer, who confirmed for me later that it had indeed been the "project from hell." Since then I have always gone with my gut and tactfully not accepted potential clients I felt might turn into future nightmare situations.

—Jeff Fisher,
Jeff Fisher LogoMotives, Portland, OR

"Monitor closely, act quickly, communicate clearly."

—Bob Bapes,
Bapes & Associates, Oak Park, IL

Let's Do Lunch... Again

Meeting twice helps establish a more personal relationship with your client

Ask to meet twice at the beginning of each project with the client. The first meeting, of course, is to get the ball rolling—to define the parameters of the project and the special needs of the client. The second meeting, which should take place soon after the first, is when you'll come to the table with a truckload of questions. It's important to remember that the client is hiring someone to solve their problem in its entirety. You as the designer cannot rely on them to remember every detail and predict every potential tripwire. Many clients, in fact, are so involved with the details of their own jobs that they can rarely visualize the full extent of the project. Because of their preoccupations, clients rely heavily on your expertise, and they are often extremely grateful if you have the ability to foresee and prevent minor (or major) conflicts that could arise without warning.

Of course, your truckload of questions can always be unloaded during the first client meeting, but I've found that meeting twice early on nurtures a more personal relationship and contributes to the important sense of trust that is vital in every client relationship. More importantly, it allows both you and the client the opportunity to step away from the immediacy of the situation, and assess how the details inform the bigger picture.

—Scott Boylston,
Savannah College of Art and Design, Savannah, GA

Lose a Client, Learn a Lesson

Just as exit interviews for former employees have become more popular, designers are trying to make the most of terminated client relationships by learning as much as they can about why the clients chose to leave. Here are some questions that might help you improve future client relations:

- What (if anything) about our service was not satisfactory?

- Were you happy with our responsiveness to your needs?

- Did you feel we had a good understanding of your market?

- Was our pricing clear?

- Did you feel we communicated well and frequently enough?

- Did you feel we were leaders in the relationship? (This is key, as most clients want a strong opinion and a business partnership with their design firm.)

The questions you ask are less important than getting your ex-client to talk with you candidly. While they talk, listen carefully to the subtext so you can glean any underlying reasons for their departure.

Always do this verbally (asking them to complete a written survey/evaluation at this point sends the message that you don't care enough about them to sit down and talk). Or, if the situation is too uncomfortable for you to deal directly with the client, hire a third party, such as a management consultant accustomed to working in your field. What you learn makes the investment worthwhile.

—David C. Baker,
ReCourses Inc., Nashville, TN

Service with a Smile

In today's business climate, there are many factors beyond your control. Mergers and acquisitions, relocations, personnel changes or other events may result in terminated client relationships, and there's literally nothing you can do to change that.

What you can affect is how your clients perceive you and the services you provide. To ensure that your clients stay happy, follow these basic customer service guidelines:

- Find the right clients in the first place. No amount of great service will salvage relationships that are not meant to be. When you think a potential client may be a bad fit for your firm, trust your instincts.

- When you take on a client, formalize the relationship so that you surface potential issues at the outset. Develop a checklist of questions whose answers help you determine how this client wants to be treated. Develop a design brief (in close conjunction with the client) so both sides know the project goals, expected outcomes and development stages.

- Establish internal standards for customer service. Address such issues as how promptly client phone calls should be returned, how soon to invoice after services have been rendered and how often clients should be updated on the project's status. Make sure you communicate these policies to your employees.

- Be attentive. Once you've established formal customer service standards, use them.

—David C. Baker,
ReCourses Inc., Nashville, TN

Diversify Your Client Base

Building a balanced client list helps you avoid dramatic business downturns

Losing a key client is one of the most common reasons design businesses fail. And when the key client is your only client, the situation is even worse. Avoid this potential pitfall by making sure no single client represents more than 25% of your billings. Diversify the types, sizes and industries of clients you serve to stay flexible during good times and bad.

—Adapted with permission from "Stormy Weather," HOW magazine, December 2001, by P. M. Knapp

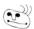

Play Show-and-Tell to Persuade Clients

Vendor samples can be your biggest pitching tool

Clients sometimes have trouble visualizing the final product, which can lead to some hesitancy to give the go-ahead on a project. Paper dummies, printed samples and finishing and bindery samples help your client visualize what they'll be getting for their dollar. Being able to see, hold, touch and measure the weight of a folded, bound dummy on blank stock helps the buyer understand why wire costs more than saddle stitch and why a good foil stamp costs more than a metallic ink.

As your client studies the dummies, ask her, "Which of these do you think your intended client will remember? Which of these pieces will best help brand your company as a high quality corporation that pays attention to detail?" And the last question: "Isn't it worth the extra 3, 30, 60 (or whatever) cents per unit for this extra feature that makes the piece sing?"

Your print vendor should be able to provide folded, trimmed and bound dummies in the actual stocks you intend to use. Your finishing vendor can use existing dies or foils to test die cutting, embossing, letterpress, foils and other special effects on the actual stocks to be presented along with the bound dummies. Armed with these samples and color printouts of your proposed design, you'll have much better luck getting those extra dollars for your print budget.

—Jackie Cuneo,
Watermark Graphics, San Francisco, CA

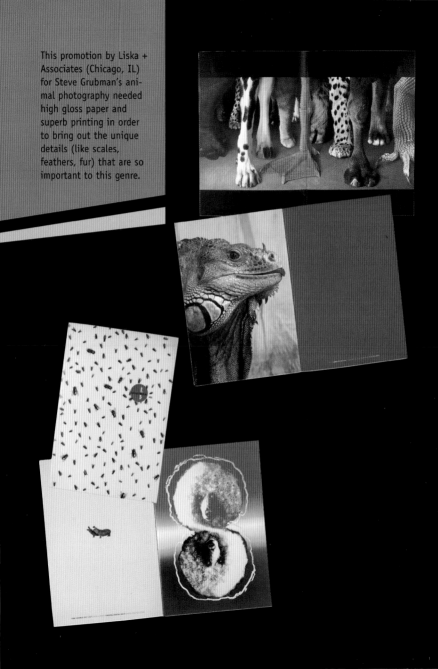

This promotion by Liska + Associates (Chicago, IL) for Steve Grubman's animal photography needed high gloss paper and superb printing in order to bring out the unique details (like scales, feathers, fur) that are so important to this genre.

Make the Best of a Confrontational Situation

Don't back down, but make sure the outcome is productive

When you're dealing with other human beings, conflicts—and the confrontations that result—are inevitable. How you handle conflict can make a huge impression on clients, suppliers and colleagues alike.

Whether the issue is a supplier's failure to deliver as promised, a client's failure to pay or creative differences, you'll encounter confrontation many times during your career. First rule: Don't balk. If a confrontation is necessary, make sure the outcome is a productive one. Here's a step-by-step guide to those sticky encounters:

1. Pause. DO NOT REACT IMMEDIATELY. Take a deep breath and . . .
2. Assess your goal. What needs to be accomplished? If your printer made a mistake, do what's needed to make sure the piece is reprinted in time and worry about blame and vindication later. To do this you must . . .
3. Get back on the same side. This is the secret to salvaging the relationship. To your printer say, "We will both be happy with this project when it's done, and that's my goal." To your client say, "This project is important to me. It will reflect on me almost as much as on you, so I will do my best to make sure this issue is resolved fast." Also, make sure you . . .
4. End on a positive note. What you say last will be remembered first. To your printer say, "Jim, thanks for working with me on this, I appreciate it and we'll make this look sharp." To your client say, "My goal is to work with you to ensure you are completely happy with the final product."

—Ryan Harper,
Harper Creative, Millville, UT

"When you have a good rationale for your design solution you can employ it to both explain your idea as well as defend your design solution."

—Robin Landa,
Ideaworks, New York, NY

Talk to Your Printer

Want an (almost) stress-free relationship with your primary vendor? Choose well, talk often and talk straight

All too often designers (especially those pressured by impossible budgets or deadlines) succumb to the lure of the low bid or the "Sure, we can turn that around for you in four days," assurance. The surprises—and the tears—come later, when job quality is not as expected or the printer hits you with an unexpected cost. To avoid the anguish, follow these basic guidelines:

Develop a list of solid, reputable vendors whose work you've seen and who have good references.

Match the printer to the job. Learn about the capabilities, strengths and weaknesses of your potential vendors. The smaller shops often bid more competitively on short-run, limited-color projects, while the big shops work more efficiently on full-color, large-run jobs.

Develop a thorough bid package. Make sure it includes:

- a specification sheet that lists all quantities and sizes as well as ink, paper, folding, binding, and finishing requirements

- a project outline with production and distribution schedules

- a sample, mock-up or storyboard of the product

- mark-ups of a key spread to show color breaks, bleeds, folds, custom die cuts, etc.

- a contact list of all involved personnel

- a request sheet asking for samples, references and pricing

Always ask for references before you use a printer. Ask for at least four, and check them all.

Watch out for the low-ball bid. The printer may be trying to get your business but may hit you with unexpected costs later.

Negotiate costs with your top candidate. Don't negotiate costs with all your potential printers. Instead, wait until you've found the best printer for the job, then talk money.

Know what "rush" means and what it will cost you. Ask your printer about the fees that result when you need faster service. Rush charges can be disastrous to a small budget.

Bring your printer into the project early. If you have a good working relationship with your printer, ask him to collaborate early on. He often can advise you on the best way to configure the job to save time and money.

When problems arise, don't panic. Most problems result from lack of communication. Before a job goes to press, triple check that you've given the printer all the information he needs to do it well. When the inevitable occurs, don't waste time placing blame or slinging barbs. Focus on what needs to happen to correct the job and get it to the client on time.

Develop long-term relationships with your printers. There's a lot to be said for trust and good service. You may not always get the lowest price, but you'll know the job will be done well and that the printer will deal fairly with you.

Earn the Respect you Deserve
as an In-House Designer

What do you do when you're the only creative in sight? You're supervised by a nondesigner, working among nondesigners, in a non-design environment. And because no one around you understands what you do or how you do it, getting the adequate time and resources to do your job—not to mention earning the respect of your nondesign peers—can be an uphill battle.

Design management and brand strategy consultant Peter Phillips offers the following tips for asserting—and promoting—yourself as an in-house designer:

Understand design's role in your company's success. When you get a good handle on how design affects the bottom line, you'll have a better understanding of the value you personally offer, and it will change how you present yourself.

Speak the language of business, not design. Structure your conversations with internal clients around the business problem and how to solve it. Don't talk about typefaces and colors. Talk about return on investments, market share and shortening the sales cycle.

Educate your in-house clients about the design process. Make sure they know what each design project requires— in time, money and resources. Sometimes unrealistic expectations are the problem. When this happens, make sure your client knows what they'll be sacrificing if they want a design in a few hours versus a few weeks.

Prepare a design brief. A well-written brief solves most problems you may have with internal clients, because it serves as your project road map and letter of agreement. Together, identify the problem that needs to be solved, project goals, desired outcomes, phased time lines for the

work, costs and their justification and a measurement system for the design's effectiveness.

Be a strategic partner, not a service provider. You are an expert, and like an attorney or accountant, you provide valuable knowledge. Don't act like an order taker and you won't be perceived that way. If you want to be taken seriously, present yourself as an equal partner in the process.

Promote design alliances within your company. Instead of waiting for internal clients to request your services, be proactive. Think about how design affects each department, then set up meetings with department heads or invite yourself to staff meetings to discuss how a partnership with you could benefit them.

Educate your clients on how to review design work. Ban subjectivity from design reviews by establishing ground rules that prohibit the use of words like "I think," or "I believe." Instead, teach clients to think objectively: "This solves the design problem because..." or "This doesn't achieve our stated objectives because..."

—Adapted with permission from "Can't Get No Respect?" HOW magazine, June 2002, by P. M. Knapp

Maximize Your Meeting Time

`Make meetings effective and fun`

Hate going to meetings? You're not alone. Experts estimate that managers spend at least two hours per day in meetings—and at least one-third of that time is wasted. Why? While a lot of meetings are long on doughnuts, they're short on the essentials that guarantee a productive outcome: a specific, stated purpose; an agenda; a defined time frame; effective leadership; and some basic ground rules. You can make the most of your meeting time. Here are a few basic guidelines:

Make sure it's necessary. With all the high-tech tools available—e-mail, instant messaging and video conferencing, to name a few—it may not be necessary to meet in person.

State your purpose. You should be able to define the purpose of your meeting in one or two sentences. Be specific.

Decide who should attend. Each attendee should be there for a specific reason, and no one should wonder why he or she was invited.

Set an agenda. List the items you will review and discuss. Consider setting time limits for each item and identify the person responsible for moderating each discussion.

Set the time frame. Let meeting attendees know when it will start and end. Keeping it to one hour or less will maximize productivity. A good starting time is one hour after most attendees arrive at work.

Choose the best venue. Consider climate, ventilation, lighting, optimal viewing of presentation materials and space required for writing notes or plugging in laptop computers.

Send a complete invitation. Your invitation (whether it's an e-mail or typed memo) should include the date, time and location of the meeting.

Make sure participants are prepared. Provide not only the agenda, but also any relevant background materials as far in advance as possible. Be clear about what you expect from attendees in terms of preparation.

Start on time. Don't wait for stragglers. And never be late to your own meeting. If someone arrives late, don't waste the punctual attendees' time by reviewing.

Provide snacks. While doughnuts are a tried-and-true favorite, you might want to consider fresh fruits and juices, which provide stimulation without the sugar highs.

Assign a moderator. Every meeting should have a facilitator or "topic keeper," the person who keeps discussions focused and on track. This role requires diplomacy, tact, good listening skills and the ability to think on your feet.

Keep and send minutes. Someone other than the meeting organizer should record the meeting's minutes and distribute them afterward.

Track "action" items. The recorder should also keep track of action items and who was assigned to be responsible for them. Distributing the minutes after the meeting reminds everyone of their responsibilities.

Mind your manners. A good business meeting is one where all the players show courtesy and respect.

—Adapted with permission from "Meeting Makeovers," HOW magazine, December 2001, by P. M. Knapp

> **"That which does not kill me will make me stronger."**
>
> —Frederick Nietzsche,
> from Twilight of the Idols

Design, of course, is a problem-solving discipline. So the greater the challenges you face, the greater your opportunities to find brilliant solutions, right?

Yeah, right.

As if tight budgets, impossible schedules, difficult clients and combinations of all of the above aren't enough to keep you on your toes, there are the more creative obstacles to deal with. Concepts that just don't lend themselves to visual metaphor. Artwork that's less than professional quality but must be used anyway. Copy that's so long it threatens the integrity of your design. Restrictive branding guidelines. Creative block. And on and on.

Contributors to this chapter have been to those mountains and scaled them. In the following pages, they share their strategies and solutions to a wide range of creative challenges, including many you've been up against and some we hope you'll never encounter.

CREATIVE CHALLENGES

REAL-WORLD SOLUTIONS TO DESIGN OBSTACLES, FROM
ALBATROSS ARTWORK TO CREATIVE BLOCK

Use Photoshop Tricks to Transform Bad Artwork

Montage, ghosting and other techniques save the day

As art director of a magazine geared to the screenprinting industry, I work with screenprinting shops that, although innovative in their field, are not set up for photo shoots or publication art production. So I receive color copies, low-quality snapshots, low-dpi images, ink-jet printouts and other bad artwork on a regular basis.

I often montage photos or use one of Photoshop's other techniques: ghosting, adjusting levels of hue/saturation, polarizing, glowing edges. If the vector art is bad I begin to scan and drop them over photos or other art for texture or ghost them for interest. Using these tools, I can style bad images into good ones and turn my production nightmares into balanced solutions.

—Bill Parsons,
ST Media Group International, Cincinnati, OH

"Photoshop (Savior of the Design World) is often my way of

turning a sow's ear into a silk purse."

—Bill Parsons,
ST Media Group International, Cincinnati, OH

Avoid the "Sea of Copy" Syndrome

Keep legibility in mind when your piece is text-heavy

In any design piece, but especially those heavy on text, legibility is the key to reader friendliness. To maximize legibility, keep the following guidelines in mind:

> ***Type size should be appropriate to column width.*** Column widths for text should be in proportion to the size of the type. Follow this rule of thumb: Columns should be about forty characters wide for maximum readability.
>
> ***Avoid rivers.*** When word spacing is not tight enough in justified columns of text, large white spaces occur between words and look like "rivers" of white running through them. Rivers tend to disrupt the movement of the reader's eye from left to right.
>
> ***Check hyphenation.*** To avoid rivers in long bodies of justified text or extremely jagged ragged-right margins, be sure to use automatic hyphenation.

—Adapted with permission from Designer's Survivor Manual, HOW Design Books 2001, by P. Evans

Don't Let Creative Rules Bog You Down

Discover how restrictions can be liberating

The ABC television network identity is rooted in a set of brand attributes that distinguish the network from its competitors. So the network has developed a very detailed—and restrictive—set of creative rules that govern design work for the identity.

Troika Design Group creates prime-time network commercial packages, which include animated commercials as well as identities and promotional packaging. To create these packages, Troika must work within ABC's strict guidelines, using only those elements in its approved design palette: flat yellow color, black-and-white sequential still photography, reductive design and eclectic music that ends with ABC's four-note signature.

With so many restrictions, and just a handful of graphic devices at designers' disposal, how can any creativity take place? For Troika, which is working on its fifth season of network packages, the added challenge is to avoid being repetitive. "We can't let things get boring," says Troika creative director Dan Pappalardo. "While keeping the brand messaging consistent, we have to use the element of surprise to keep viewers interested."

Troika's solution? Reinterpret the rules whenever possible. High-contrast photography is used as bold graphic accents. Narrative graphic animations show the unlimited use of dots and the color yellow, and flat space is expanded to three dimensions without breaking the flat color rule. Troika also introduced new graphic symbols, including a dot-matrix navigational arrow, as iconic devices.

"On first glance, working within such a limited brand palette appears very constraining to a designer," explains Pappalardo. "But we've found the opposite to be true. The constraints force us to push the creative possibilities. The truth is, the constraints aid the entire creative process. They add focus and guide our decision-making. And the criteria for judging the design are made more concrete, so there's less room for subjectivity."

Troika Design Group (Holly... stayed within ABC's strict g... when they created these te... commercials.

One of the biggest obstacles many designers face is low-quality artwork. When you're presented with low-resolution, amateurish, blurry or damaged photographs slated to become the focus of your design piece, what do you do?

The ideal solution, of course, is to get good photographs in the first place. But sometimes that's simply not within your control. In this case, you're forced to make do with what you have on hand. That's when your creativity—and some advanced Photoshop skills—come in handy.

Low resolution. If you plan to use the image as a design element rather than a feature photo, you have slightly more options. First, res up the image to printable quality (300 dpi minimum) and apply a filter to compensate for pixelation. Then experiment with Photoshop tools, such as the Dry Brush Filter, blurring the image or screening it back and using it as a background texture. If there's no way around using the photo as a major element of the design, there are a few ways to trick the viewer's eye (based on the understanding that they can mentally interpret incomplete information). Here's how:

■ Always res up the image first (300 dpi minimum).

■ Use the Unsharp Mask Filter, which provides greater control than the standard Sharpening Filter. In CMYK mode, try the Unsharp Mask on just the black channel to enhance detail without creating artifacts in the color channels.

■ Add a subtle amount of noise or photo grain to break up the pixelation a bit. This is also an effective step to help make the photo more even and avoid problems such as banding.

Bad JPEG compression. Often bad JPEG compression results in blackness in the image's color. Convert the file to LAB mode and subtly blur the A and B channels while keeping the L channel the same. This retains sharpness while redispersing the color and providing smoother transitions.

Bad color. You can adjust the image's color using either the Color Balance tool or by adjusting each color channel individually through levels or curves. Also try Hue/Saturation, which adjusts both the overall saturation or the saturation of individual channels.

Contrast issues. Adjust contrast via the Curve tool or by using the Brightness/Contrast function.

Bad spots. Don't underestimate the power of the Clone tool! In Photoshop 7, the Healing Brush and Patch tools are amazing. Also strip out portions of the photo while getting rid of the nonessentials or a bad background.

If you're working in RGB but the result will be a CMYK file, always work with the CMYK preview (located under View—Proof Setup) to access the various filters. This gives you an accurate preview of how your adjustments will look in CMYK and won't change the look of the file when you convert from RGB to CMYK.

—Phil Van Milligan,
Envoi Design Inc., Cincinnati, OH

Take a Trip to the Hardware Store

The hardware store is one of the coolest places to find materials for comping purposes as well as final production solutions. Metal rods, nuts, bolts, sheet metal, wooden dowel rods, rubber o-rings, jute twine and scads of other fun materials all can be found at your local hardware store. If you've developed a wonderful concept that includes little details like nuts/bolts as a bindery option or an embossed metal cover and you really need to sell the idea, having a fully-comped solution to present to the client pays off and saves time. If the design solution is approved, most pieces found at the hardware store can be purchased in bulk either through the hardware store or online (and printers often have additional resources to work from).

—Cheryl Roder-Quill,
angryporcupine, Cupertino, CA

"Continue to do all you can to flex your creative muscle so that your right brain is in tip-top form."

—Christine Holton Cashen,
motivational speaker, Dallas, TX

Let Questions Lead You to the Design Solution

Creativity tips from a veteran design educator

Richard Wilde, chairperson of the advertising department at New York's School of Visual Arts, has been a designer and educator for more than 30 years. He has developed a wide range of exercises to help his students learn how to spark their creativity, but he says true creativity requires the following four elements:

> ***Start from not knowing.*** Admitting that you don't have a clue how to solve a problem is a much better place to start, he says. That allows you to open up to the problem.

> ***Turn the problem into a question.*** Asking questions about a problem helps open up new ideas. It's a technique that every designer can apply on the job.

> ***Ask the right questions.*** Learning which questions to ask is essential, although it's really a matter of trial and error. Giving yourself permission to ask questions allows you to connect to the problem from a new angle.

> ***Let the problem tell you how to solve it.*** This is the tricky part, but it's essential. When you're in a creative state, you'll get answers by observing and responding to the problem.

—Adapted with permission from "Connecting to the Problem," HOW magazine, April 2001, by Susan E. Davis

When Everything Goes Wrong

We once designed a charity invite for the New York chapter of the
Gay and Lesbian Task Force containing an actual plum and a
banana. 5000 invitations were to be produced and sent out in July
(in the middle of a New York heat wave). Knowing that we might
run into problems, our producer organized everything to the
minute. All New York addresses were to be delivered by messenger,
the rest by courier. We had standing orders for 5000 plums and
5000 bananas. Everything was in order and we felt safe.

On the day the conversion house was supposed to wrap the fruit
in printed tissue paper, combine it with cards and box them, we
had 5000 bananas but no plums. The plums would be arriving in
the afternoon, we were promised. So we went ahead and wrapped
and boxed the bananas. No plums arrived that afternoon. Or the
next day. By the time the plums arrived the day after, the wrapped
bananas had turned brown and were leaking. So out went the
bananas, the plums got wrapped, the new bananas showed up, but
now there was not enough pre-printed tissue paper to wrap another
5000 bananas. Reprinting of tissue paper takes two days.

And, you guessed it, the plums went bad.

In the end, most packages arrived fine,
and the dinner was a success. It just goes to show
that with a little patience and perseverance even
the worst situations will work out eventually.

—Stefan Sagmeister,
Sagmeister Inc., New York, NY

Don't Forget the Homemade Touch

For small-run jobs, handcrafted is sublime

If quantities are small and time permits, produce the designed pieces by hand, yourself. Wonderfully crafted, handmade invitations, announcements or promotional items are often more suitable than super glossy, overproduced pieces. The message you send is clear: I have taken the time to create something specifically for you (the client).

—Cheryl Roder-Quill,
angryporcupine, Cupertino, CA

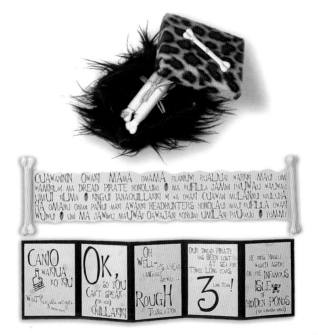

This Cannibal King invitation was created for a child's birthday party. A "native" language was created and printed on a scroll complete with bone finials. The invitation was then inserted in the custom-made faux fur boxes and sent to the party guests.

"But My Logo was Designed by My (Insert Relative Here)"

Convincing the client that an amateur logo just won't do

I often get poorly designed or poorly executed artwork or logos for design projects. Most often the design was created by a relative or friend of the client or the client themselves. One case involved a museum in Oregon. The yet-to-be-built facility had received substantial federal funds for development, and I was contracted to design a high-end, four-color magazine insert and brochure to promote private and business donations. Then I was sent the hand-drawn logo for the grass-roots organization. It was very rough and amateur-like, and I knew I had to convince the client that I needed to rework or redesign it in order to incorporate it in the promotional materials.

I knew I was walking a political tightrope on this project. I was smart enough to know that telling the client his logo "sucked" was not appropriate. In a meeting with my client, I learned that the image had been created by one of the organization's most valued volunteers. I carefully explained the need for a more polished image to present to large private and corporate donors. I ended up using the logo's basic design, cleaning it up and giving it a more professional appearance.

Presenting two versions of the designed piece—one with the existing logo and one with my cleaned-up version—made it very clear to the client which would be more effective, and the woman who drew the original was thrilled at the improvement I made on her concept.

—Jeff Fisher,
Jeff Fisher LogoMotives, Portland, OR

Don't Become a Part of the Problem You're Trying to Solve

`Use relaxation and humor to jump-start your creative engine`

Solve problems when you are not bitter, tired, cranky or stressed. You cannot create or promote your ideas while in these mindsets. Take your job seriously but do not take yourself too seriously. When your mind relaxes a bit, the right and left hemispheres work together and ideas are abundant. Get some props and work on some "ha-ha" (stress reduction) for the "Ah-HA" (great ideas!)

All of us can feel bogged down with the day-to-day responsibilities. Identify your "energy gain" time—that's when you have the most energy and feel most creative in the day. Is it morning or afternoon? What about your "energy drain" time? If possible, work on the most mundane or day-to-day activities during your low energy times.

—Christine Holton Cashen,
motivational speaker, Dallas, TX

"It is a perfect day when ideas flow like lava from your mind volcano and the client is thrilled with the results."

—Christine Holton Cashen,
motivational speaker, Dallas, TX

Create a New Context for Photo Images

Invent new ways to use limited photographs

My company was hired to create a poster for a dance company in Austin, Texas. I was given photographic images of two women who were no longer in the company. The images were good—interesting body shapes, etc.—but the catch was that I was not to use their faces.

The performance being promoted was called "Jass: A Syncopated Journey in Jazz." To maximize the use of the photographs while adhering to the client's limitations for their use, I created a mostly typographical piece that referenced the Blue Note design aesthetic, incorporating the two bodies as design elements, with their faces/heads cropped or de-emphasized in a way that seemed natural within the playful, organic structure of the design. It was a two-color job on colored paper, making for a three-color overall effect.

—Blake Trabulsi,
Zócalo Design, Austin, TX

Hired to create a poster for an Austin, Texas, dance company, Zócalo Design was given a photo of two dancers in motion, but cautioned that the two women should not be recognizable, as they were no longer with the company. To make use of the strong photo composition while adhering to these restrictions, designer Blake Trabulsi created a new context for them in an intensely typographical solution.

Photo credit: José Medina

Tapestry Dance Company presents

JAZZ

A Syncopated Journey in JAZZ

October 19th & 20th
8:00pm

The Paramount Theatre
713 Congress Avenue
Austin, TX

Call 469-SHOW for tickets!
www.startickets.com

Funded in part by the **City of Austin**
under the auspices of the **Austin Arts Commission**

Jump-Start Your Team's Creativity through Brainstorming

Here's how to maximize team brainstorming sessions

Need a group ideation session to jump-start a project? Follow these tips to get the most from your meeting of the minds:

Choose the right time of day. Most experts agree morning is the optimum time of day; Friday afternoons are the worst. Consider planning a brainstorm over lunch or tea.

Keep it short. Two-and-a-half to three hours is optimal. All day is generally considered too long.

Find an interesting setting. Get out of the conference room. Consider a field trip to the park, the zoo or the local aquarium. New surroundings help stimulate creativity.

Feed their brains. Snacks are always a good idea. Stay away from sugary foods, which produce a quick high then an abrupt low. Fresh vegetables and fruit are great brain foods.

Be open and respectful. Foster a safe, nonthreatening environment for brainstorm sessions. Everyone, regardless of their rank in the company or group, should feel comfortable contributing. One of the cardinal rules of brainstorming is to listen with open ears and an open mind.

Go for quantity, not quality. Record any and all ideas. You can narrow them down later, and discarded ideas may be great fodder for other projects.

Keep the energy high. Quickness drives participation and fuels creativity, so don't be afraid to speed things up. If the energy level is low, kill the session and reschedule.

Don't be afraid to have fun. Play with blocks or modeling clay. Shoot Nerf guns at each other. Paint pottery or color. These activities get the creative juices flowing. Another creativity-boosting technique requires that you banish tired, overused words from your meetings. As a group, decide on the blacklisted words at the beginning of the meeting. Throw Nerf balls or shoot water guns at anyone who uses a word from the list.

—Adapted from "Meeting Makeovers,"
HOW magazine December 2001, by P. M. Knapp.

"Be a lifelong learner. Read. Go to the theater. Attend a modern dance performance. Read. See an independent film. Catch a special exhibit at your local museum. Read. Take dance lessons. Travel. Watch an old classic film. Read."

—Robin Landa,
Ideaworks, New York, NY

Fight the Fatigue Factor

Fatigue—that shoulders-aching, headache-making, concentration-breaking productivity killer—is a common malady among design professionals. Prevention, of course, is the best medicine. To head off the back, shoulder, neck, head and eye strain that ultimately dilutes your creativity and efficiency, take these precautions:

- ***Step away from your computer at least every hour.*** Walk around the office. Stretch. Taking frequent breaks promotes blood flow and helps you sustain brain power.

- ***Reduce eye strain.*** Stop every 15 to 30 minutes and focus on something in the 15' to 20' distance for 30 seconds. When you're working longer stretches, lean back in your chair and close your eyes for five minutes.

- ***Avoid repetitive stress injury.*** Key with your wrists straight, not bent. If you find that your wrists tend to rest on your desk surface, use a wrist pad under your mouse.

- ***Make sure your monitor has a high refresh rate.***

- ***Use a glare filter over your monitor.***

- ***Set your colors to neutral tones.***

- ***Position your monitor lower than your eyes.*** This makes you blink more and reduces eye strain.

- ***Invest in an ergonomic chair and keyboard.***

—Ryan Harper, Harper Creative, Millville, UT; and Gary Unger, Graphics Crisis? Call Gary!, Atlanta, GA

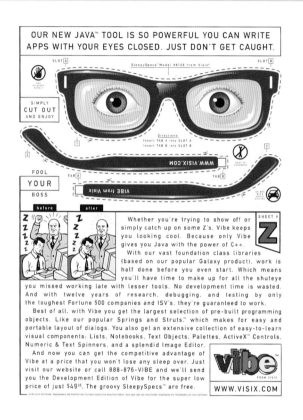

These glasses, by West and Vaughn (Durham, NC) are the perfect tool for resting tired eyes and fooling the boss.

Don't Let Lengthy Copy Get in Your Way

`Cut copy or adjust type to preserve your layout`

It's crunch time, and the copy for the brochure you're working on is too long for the space allotted. What to do? You have a few options, but cutting copy or adjusting type are the quickest and least damaging to your layout.

ADJUSTING TYPE

In a tight-fit situation, consider making some of the following type adjustments:

- Choose a condensed version of your chosen typeface, or reduce the horizontal scaling slightly

- Justify type instead of setting it to ragged right

- Reduce letter spacing and word spacing slightly

- Minimize leading

- Choose a typeface with a low x-height (lowercase characters that are small in relation to the uppercase characters). These include Garamond, Times Roman, Caslon and others.

CUTTING COPY

If your writer or client resists, explain that disproportionately long copy dilutes the piece's overall message. Explain that the type must be large enough to be reader friendly, and that headlines, photos and other attention-getting elements shouldn't be sacrificed to make room for it. If they need further convincing, show examples of how the piece will look with the shorter copy versus the unedited copy. Then cut what you can.

- **Delete unnecessary words.** "Each and every one" can be replaced with "each" or "all."

- **Use contractions.** Replace "do not" with "don't" and "is not" with "isn't."

- **Shorten phrases and delete unnecessary ones.** Phrases such as "in my opinion," or "it is my belief that" can be eliminated. Phrases such as "in a timely manner" can be shortened to "promptly" or "quickly."

- **Delete unnecessary prepositional phrases.** Phrases such as "the essence of the work" can be shortened to "the work's essence."

- **Look for repetition.** If more than one sentence seems to say the same thing, you may be able to delete it without affecting the meaning of the paragraph or passage.

- **Be mindful of style.** Don't violate any style rules that may apply to the piece you're working on. If your client has a style guide, adhere to it.

Create Dramatic Imagery
with Your Scanner

Form a beautiful partnership between your scanner
and found objects

Often, project budgets are limited and stock photography isn't an option (the client cannot justify the costs, no matter how inexpensive the images may be).

I recently completed a CD package for a musician in the UK. She creates organic, dark folk music. She likes flowers, butterflies and moths and wanted to include some of these elements in the CD design. My initial concept included an image from a well-known royalty-free stock agency, and she liked it so much she requested we find more images like it. The project budget didn't allow for more than one purchased image, so I decided to create images similar to the approved one by scanning objects. She mailed me a package of dried flowers and other assorted items, and I placed them on the scanner bed, scanned them in and created a beautiful ghosted montage in Photoshop. The final images look awesome, and we achieved our goal without exceeding the budget.

—Cheryl Roder-Quill,
angryporcupine, Cupertino, CA

This wedding invitation, which was designed by Cheryl Roder-Quill of angryporcupine (Cupertino, CA), uses butterflies and moths as natural elements in a "traditionally-structured wedding invitation that uses nontraditional elements."

Text within the invitation image:

With joyous hearts, your presence is hereby requested to join Scott & Tracy in a celebration of love to be held at Daniels Summit Pass, Highway 40, Heber City, Utah, located in the United States of America. Visit www.danielssummit.com for information.

Anticipate Problems with Multilingual Copy

Setting text in different languages changes its length

When designing multilingual versions of a piece, work with your copywriter to accommodate differences in the length of copy set in multiple languages. For instance, the Chinese version of a body of text can run 40% shorter than the English version. The same text run in German will be 20% longer.

—Adapted with permission from Designer's Survival Manual, HOW Design Books 2001, by P. Evans

"I find that most creatives love a challenge and their creativity thrives under a pinch."

—RaShelle S. Westcott, creativity coach, Newport Beach, CA

Tug-of-War or Balancing Act?

Prevent stress from wreaking havoc on your professional and personal life

If you're bogged down by your work schedule, remember to breathe, breathe, and then breathe some more. It will bring you back to yourself and help you gain perspective and a sense of calm. No matter what it is that seems so overwhelming, you can handle it. Really. You've done amazing things before and you will do them again. Now is no different. Trust that incredible creative mind of yours and let it do what it does best—create!

And with such a busy schedule, how can you juggle your professional productivity with your personal life? Simple. You don't. Work and home life aren't separate—they're two pieces of a whole, each one complementing the other. It's not a tug of war for your time, energy and creativity—it's one continual expression of who you are and what you care about. Are you spending those precious resources on that which matters to you?

—Katie L. Anderson,
speaker and performance coach,
Santa Monica, CA

Before Designer Software:
A Handmade Mechanical

**Don't let technological shortcomings
get in your way**

Long before the Macintosh made our lives so much easier, I
volunteered to design a poster for my high school's 10-year
reunion. The challenge was largely a mathematical and technical
one: I created a design that featured the word "REUNION" in
huge letters as the dominant image on the poster. I designed a
typeface that was made up of many tiny rectangles, so that I
could create each of those letters out of the high school pictures
of all of my classmates. There were 475 people in my graduating
class, and I decided to use every one of them. My first challenge
was to configure the letters so that the design would accommo-
date exactly 475 photos. I had decided that the *I* and the *O* in
"REUNION" would remain a solid color to represent the number 10.

With the remaining letters I tried to figure out how to get
exactly 475 photos to work. After lots of adding, subtracting and
reconfiguring, I designed letters that worked, but I had space for
486 photos. The only solution that seemed plausible (and unno-
ticeable) was to lop off an extra row of photos from the right
edge of the *E*. That brought the total number of slots available
down to 477. Because the letters already had a stairstepped look
to them, I plucked the remaining 2 photos from the top left and
bottom left corners of the *E*, which improved the integrity of this

homemade typeface in the end. And unless you were looking for it, you'd never know the *E* was too thin.

The next challenge was producing it. My only resource for images was my actual yearbook. So I very carefully cut out each picture. I had to use (or rather, ruin) a second yearbook—my brother's—because there were pictures on both sides of the page.

And there were a few people whose pictures had to come from a different year, which were a different size, which meant that I had to use the good old stat camera to shoot them to match the size. I then assembled on boards each letter, comprised of hand-cut photos. I then made masks of the letter shapes so that the edges would be clean, and voila!, an old-fashioned, hand-done mechanical from hell.

But it worked. And my ultimate validation came when the poster was included the following year in the Type Director's Club annual.

And did I mention how bad our hair was in 1977?

—Willie Baronet,
GroupBaronet, Dallas, TX

Your Advantage

When designing original logos for our clients, we work through the entire design process and come to a completed, basic design—almost without exception—in black and white. Once the logo design is finalized, we then look to incorporate color, texture, and dimension to the logo where it might be appropriate.

There are many reasons we like to work this way, but one of the more notable ones is that it gives us the flexibility to cater to the budget of the client. Sometimes the final version of the logo is the same black and white version. In some instances, that's because the client simply loved the simplicity of it. In many cases, it also has to do with the client's budget.

While some may see our method as a self-imposed restriction (or a set of handcuffs), we disagree. We see it as a way to maximize our creative output— perhaps in the way a hearing impaired or blind person's other senses are much more finely tuned.

Over time, our design teams have found that they actually prefer presenting logo concepts to clients in black and white, because it eliminates a lot of possible distractions. (Ever had a client immediately rule out your favorite design because you had inadvertently put it in red—and they hate red?)

—Pash,
Digital Soup, Culver City, CA

Here are some examples of logos that were created by Digital Soup (Culver City, CA), with the original approved black-and-white version to the left, and the final version to the right.

Crack Creative Block

Every creative professional faces it from time to time. Call it creative block, the black hole, brain plague, designer's constipation or whatever—chances are you've suffered from it and so has every other designer on the planet. Some creatives have developed their own home cures for creative block, and on the following pages, we persuaded a few to share them with you:

TRIED AND TRUE TECHNIQUES

We have lots of ways to unlock our "creative handcuffs." Here are a few we've incorporated with great success:

- look at work you've already done, or at work of people you admire, especially if it's in a different design discipline

- read a trade journal or book on a related topic

- talk to people who aren't in the business

- go to the craft or hardware store

- take a field trip

- leaf through a clip-art book

- do something that inspires you: take a walk, sing, garden

- draw on butcher paper

—John Sayles,
Sayles Graphic Design, Des Moines, IA

NEW YEAR RENEWAL

Each New Year's Day, I ensure that my creative well will not run dry. With calendar in hand, I choose one day each month that is devoted to "creative renewal." These days are sacred and planned well in advance. They are exchanged for an alternate day only if

something rare and unavoidable arises at the agency. On these days, I visit the wonderful museums, galleries, libraries and theaters we're blessed with in New York. On occasion I invite someone I admire to lunch for an inspired conversation. This usually takes place on a Friday, begins with a good breakfast near my first destination and continues nonstop until evening, when I may end the day with a film. I record what I have seen in my journal in the form of collage, drawings and notes. When I look back over a year of "days of renewal," I relive them with great relish. This is a treasured personal luxury which has benefited my clients enormously over the years.

—Ken Carbone,
Carbone Smolan Agency, New York, NY

ILLUMINATE THE DARK ALLEY

Creative block is sometimes more like looking down a dark alley than failing to be creative. That alley has many opportunities, but I fail to see them because there is insufficient motivation or navigation or even distaste. I realize I'm lacking the knowledge, support or insights necessary to complete the creative cycle. Or I may have a vision that's flawed and I can't find another vantage point. Creativity sometimes means putting different ideas together in unique ways that invite curiosity and experimentation.

Sometimes I need to get out in the world and see how other people live their lives. I find that putting myself in unfamiliar places or situations puts my mind in a different mode. I purposely try to place myself in situations that are uncomfortable, challenging or even embarrassing. Participating at Burning Man in the middle of a Nevada desert last year opened my mind to how other creatives express themselves. Forget about what you know and be open to what others can teach you.

—Tim Bachman,
Bachman Design Group, Dublin, OH

LOOK TO OTHER SOURCES OF INSPIRATION

In art school I learned that when I took a course in economics or something else I really wasn't interested in, it lead to a broader range of conceptual thinking in my creative work compared to those quarters loaded with creative courses. Over the years, I've also learned that reading something technical or dull when I'm creatively blocked doesn't necessarily inspire me but always opens my mind to more original thinking. For example, the artwork I've done in my spare time over the last 18 months started after reading *Consilience* by E.O. Wilson, a biologist and cultural scientist.

—Rob Gemmell,
Addwater, San Francisco, CA

USE THE SYSTEMATIC APPROACH

First, I try to follow a systematic approach to identifying the objective for a given communication: knowing the audience, establishing goals, setting a priority of communication, researching, brainstorming verbally and visually. Using this method, a person or visual team should be able to come up with various approaches to fill the communication objectives. However, when that brilliant idea is not banging on the door, here are a few tactics I use to at least open a window:

> **Write it down.** I begin by making a list of words and sketching pictures that relate to the objective. I may repeat this process throughout the project.

Do what I know. If I'm still having major mental block, I'll busy myself with something I'm comfortable with to ease the stress. This includes task-oriented, production-related things like organizing research, scanning images and talking to other people about the subject. This often loosens up my mind.

Walk and talk. Walking my dogs is an excellent opportunity to brainstorm out loud. Taking a shower or driving are other ways to encourage free-association thinking.

Research innovative materials. Sometimes a new paper, a special printing technique or an inspirational approach to cinematic camera work in commercials are my inspirations.

Sci-fi/fantasy never fails. Sci-fi or fantasy movies help dislodge my brain from the typical "in-the-box" thinking and bring me to a fresh perspective.

If nothing else, a deadline is my surefire inspiration.

Fear can be a great motivator!

—Becky Linser,
Linser Design, Cincinnati, OH

TRAVEL AWAY FROM THE DAILY GRIND

As I write this, I'm sitting in an Internet café in Florence, Italy, overlooking the river and one of Europe's oldest "retail malls"—an ancient bridge with small shops still in operation. To break away from the day-to-day routine and blow out the cobwebs, I travel to Europe a couple times a year. It's refreshing to step away from clients, billing and the normal activities of business.

—John Riley McCulley,
The McCulley Group, Solana Beach, CA

CHAPTER 3: ROCKY RELATIONS

CHAPTER 4: CREATIVE CHALLENGES

Directory of Contributors

Katie L. Anderson
Speaker/Performance Coach
2118 Wilshire Blvd. #515
Santa Monica, CA 90403

Hal Apple
Amgen
One Amgen Center Dr.
Thousand Oaks, CA 91320-1799
happle@amgen.com

Linda Athans
Athans Design
1453 Springdale St.
Clearwater, FL 33755

Tim Bachman
Bachman Design Group
6001 Memorial Dr.
Dublin, OH 43017
www.bachmandesign.com

David C. Baker
ReCourses Inc.
P.O. Box 23030
Nashville, TN 37202-3030
www.recourses.com

Bob Bapes
Bapes & Associates
1177 South Harvey Ave.
Oak Park IL 60304
http://ideadoc.com

Willie Baronet
Group Baronet
www.groupbaronet.com

Jill Bell
Jill Bell Design and Lettering
521 Indiana St., Unit C
El Segundo, CA 90245
www.jillbell.com

Scott Boylston
Savannah College of Art and Design
Savannah, GA

Christine Holton Cahen
Motivational Speaker
P.O. Box 703032
Dallas, TX 75370
www.adynamicspeaker.com

Elaine Cantwell
spark
6525 Sunset Blvd., Suite 301
Hollywood, CA 90066

Ken Carbone
Carbone Smolan Agency
22 West 19th St., 10th Floor
New York, NY 10011
www.carbonesmolan.com

Rhonda Conry
Conry Design
21234 Chagall Rd.
Topanga, CA 90290
www.conrydesign.com

Jackie Cuneo
Watermark Graphics
950 Tennessee St.
San Francisco, CA 94107

Cynthia Fetty
Dahlia Digital
Prince Street Station
P.O. Box 594
New York, NY 10012
www.dahliadigital.com

Peg Faimon
Peg Faimon Design
11374 Kemperknoll Ln.
Cincinnati, OH 45249
faimonma@muohio.edu

Jeff Fisher
Jeff Fisher LogoMotives
P.O. Box 17155
Portland, OR 97217-0155
www.jfisherlogomotives.com

Carly H. Franklin
CFX Creative
4152 Meridian St.
Bellingham, WA 98226
www.cfxcreative.com

Rob Gemmell
Addwater Inc.
525 Market St., Ste. 200
San Francisco, CA 94103
www.addwater.com

Randel Gunter
Gunter Advertising
2912 Marketplace Dr.,
Suite 103
Madison, WI 53719
www.gunteradvertising.com

Ryan Harper
Harper Creative
P.O. Box 562
Millville, UT 84326

Gerard Huerta
Gerard Huerta Design Inc.
54 Old Post Rd.
Southport, CT 06490
www.gerardhuerta.com

Alexander Isley
Alexander Isley Inc.
4 Old Mill Rd.
Redding, CT 06896
www.alexanderisley.com

Lisa Fiedler Jaworski
Fiedler Designhaus
1873 Sir Richards Court
Finksburg, MD 21048

Bonnie Jensen
Girvin Inc.
1601 Second Ave., The Fifth Floor
Seattle, WA 98101
www.girvin.com

Kristie Johnson
Turnergraphics
2211 Piketon Rd.
Lucasville, OH 45648
www.turnergraphics.com

Denise Kalmus
Envoi Design Inc.
1334 Main St.
Cincinnati OH 45210
www.envoidesign.com

Day Kirby
Communicopia Internet Inc.
Suite 100, 1260 Hamilton St.
Vancouver, BC
Canada V6B 2S8
www.communicopia.net

Robin Landa
!deaworks
New York, NY
www.PointInfinity.com/GDS/

Becky Linser
Linser Design
134 Cleveland Ave.
Cincinnati, OH 45150

John Riley McCulley
The McCulley Group
415 South Cedros Ave., Studio 240
Solana Beach, CA 92075
www.mcculleygroup.com

Bill McDonnell
Bill McDonnell Graphic Design
3218 Rawle St.
Philadelphia, PA 19149

Catherine McNally
University of Maryland University College
3501 University Blvd. East
Adelphi, MD 20783
www.umuc.edu

Jackie Merri Meyer
Warner Books
1271 Avenue of the Americas
New York, NY 10020

Dan Pappalardo
Troika Design Group
6715 Melrose Ave.
Hollywood, CA 90038
www.troikadesigngroup.com

Shawn Parr
Bulldog Drummond
3517 Camino Del Rio South
San Diego, CA 92108
www.bulldogdrummond.com

Bill Parsons
ST Media Group International
407 Gilbert Ave.
Cincinnati, OH 45202
www.stmediagroup.com

Matt Pashkow
Digital Soup
www.digitalsoup.com

Shelly Prisella
Digity Dezigns
198 Powers St.
New Brunswick, NJ 08902

Cheryl Roder-Quill
angryporcupine
644 Stendhal Ln., Suite 100
Cupertino, CA 95014
www.angryporcupine.com

Stefan Sagmeister
Sagmeister Inc.
222 West 14th St., 15A
New York, NY 10011

Savage Design Group
Fourth Floor
4203 Yoakum Blvd.
Houston, TX 77006

John Sayles
Sayles Graphic Design
3701 Beaver Ave.
Des Moines, IA 50310
www.saylesdesign.com

Jeff Schaller
Schaller Image & Design
104 Johnson Park
Buffalo, NY 14201

Sandra Scher
Oasis
520 Eighth Ave., 25th Floor
New York, NY 10018

Ilene Strizver
The Type Studio
3 Overridge Rd.
Westport, CT 06880
www.thetypestudio.com

Peleg Top
Top Design Studio
11108 Riverside Dr.
Toluca Lake, CA 91602

Blake Trabulsi
Zócalo Design
2026 S. Lamar
Austin, TX 78704
www.zocalodesign.com

Gary Unger
Graphics Crisis? Call Gary!
4267-A N. Shallowford Rd.
Atlanta, GA 30341

Phil Van Milligan
Envoi Design Inc.
1334 Main St.
Cincinnati, OH 45210
www.envoidesign.com

Conan H. Venus
Velocity Partners Inc.
505 Riverview Bldg.
44 E. 8th St., Suite 505
Holland, MI 49423
www.achievevelocity.com

Lori Walderich
Idea Studio
1615 South Denver Ave.
Tulsa, OK 74119
www.ideastudio.com

Matthew Wearn
Suibaku
223 Queen St. East
Toronto, ONT
Canada M5A 1S2
www.suibaku.com

Rashelle S. Westcott
Creative Coach
1801 Dove St., Ste. 104
Newport Beach, CA 92660
www.getinvision.com

Special thanks to these publications and authors for permitting use of text excerpts:

Designer's Survival Manual, by Poppy Evans
HOW Design Books, 2001

HOW magazine
4700 E. Galbraith Rd.
Cincinnati, OH 45236

Constance J. Sidles, "Press Check,"
HOW magazine, February 2001
Lawrence Payne, "Corporate Colors,"
HOW magazine, November 2001
Susan E. Davis, "Connecting to the Problem," *HOW* magazine,
April 2001
Pat M. Knapp, "Stormy Weather,"
HOW magazine, December 2001
Pat M. Knapp, "Meeting Makeovers,"
HOW magazine, December 2001
Pat M. Knapp, "Building a Case for Design,"
HOW magazine,
February 2001
Pat M. Knapp, "Can't Get No Respect?" *HOW* magazine,
June 2002
Pat M. Knapp, "Why Go It Alone?"
HOW magazine, April 2001

Index

More advice, ideas and inspiration from HOW Design Books!

Inspiration is key to your success as a designer. It makes you more creative, energetic and competitive. Unfortunately, inspiration doesn't always come when and where you want it. *Idea Revolution* includes 120 activities, exercises and anecdotes that will jolt you, your colleagues and your clients back to creative life. You'll find unique, motivational solutions to virtually every graphic challenge.

ISBN 1-58180-332-X, paperback, 160 pages, #32300-K

Graphically Speaking breaks down designer-client dialogue into something both parties can understand. It details 31 buzzwords (such as "innovative" or "kinetic") related to the most-requested design styles. Each entry is defined both literally and graphically with designer commentary and visual reference materials, ensuring clear designer-client communication every time!

ISBN 1-58180-291-9, hardcover, 240 pages, #32168-K

Designer's Survival Manual makes producing top-flight work on deadline and capitalizing on new opportunities easy. It provides the insider advice you need to build successful working relationships with writers, illustrators, photographers, printers, Web technicians and more. You'll save time. You'll save money. And you'll get the job done right, every time.

ISBN 1-58180-125-4, hardcover, 192 pages, #31954-K

These books and other fine HOW Design titles are available from your local bookstore, online supplier or by calling 1-800-448-0915.